Seed Money
From Doubt to Clout

By Carole Sprunk

SEED MONEY

FROM DOUBT TO CLOUT

BY CAROLE SPRUNK

NEW DEGREE PRESS

SEED MONEY FROM DOUBT TO CLOUT

ISBN 978-1-63676-523-5 *Paperback*

 978-1-63676-059-9 *Kindle Ebook*

 978-1-63676-060-5 *Ebook*

This book is dedicated to my husband and children.
You've helped define who I am today.

CONTENTS

———

PART 1. **CHILDHOOD** 9

INTRODUCTION 11

CHAPTER 1. JUST ME AND MY MOM 19

CHAPTER 2. MY MOM GOT A NEW LAST NAME 23

CHAPTER 3. VISITING MY GRANDPARENTS IN
 NEBRASKA AND COMING HOME TO A SISTER 27

CHAPTER 4. WHAT HAPPENS IN THIS HOUSE, STAYS
 IN THIS HOUSE 33

CHAPTER 5. MOM WENT TO PRISON AND I MOVED IN
 WITH MY GRANDPARENTS 53

PART 2. **EARLY ADULTHOOD** 65

CHAPTER 1. FINALLY ON MY OWN 67

CHAPTER 2. AN ARRANGED MARRIAGE 81

CHAPTER 3. GETTING MARRIED FOR THE RIGHT REASONS 91

PART 3. **ENTREPRENEURSHIP** 103

CHAPTER 1. TURNING THIRTY 105

CHAPTER 2. LIVING ON THE EDGE 109

CHAPTER 3. TALKING TO A CUP OF COFFEE 115

CHAPTER 4. SHALL WE DINE? THE BEST IS YET TO COME 121

EPILOGUE 127

ACKNOWLEDGMENTS 131

PART I

CHILDHOOD

INTRODUCTION

———

"The day you plant the seed is not the day you eat the fruit."
— FABIENNE FREDRICKSON

The Chinese bamboo tree doesn't break ground for the first four years. In the fifth year, it could grow as much as ninety feet within the first several weeks. You are your own unique seed. You will grow when and how you are supposed to grow.

Starting at the bottom is dreadful, but having drive, tenacity, grit, passion, and perseverance helps you press forward and continue to grow. Taking the little seeds of progress and reinvesting them back into your overall goal is the only way to grow from the bottom.

We have many varieties of seeds to plant. We have family seeds. We have personal seeds. We have professional seeds. Just like a garden, we have rows of seeds that all need a different type of care. Nurtured and cared for, those seeds will continue to provide the life you want and the legacy you wish to leave behind.

As a child, the seeds you sow are different than your adolescent, adult, or even childbearing years. Reviewing

your growth goals regularly and replanting new seeds that complement the other seeds will ensure variety and many choices. Some seeds may produce things that no longer fit in with your overall goals, and that's okay. Some seeds might not grow the way you hoped for. Sell it or gift it and move on. Whatever you do, keep growing.

I have always been an active and restless person. I couldn't sit still in class and definitely didn't want to sit still at home. I am a dreamer. I had to be a dreamer. Dreams are what I've held onto throughout my life, and they've been my safe space. I had a challenging start to life with an abusive mother who chose drugs and alcohol over her family, a stepdad who did the best he could with her, my sisters, and me, and grandparents who stepped in and stepped up to finish raising me.

I grew up quickly. My mother wasn't around much when I was little, so I learned early to fend for myself. I made my own meals before I was tall enough to reach the counter and spent a lot of time taking care of my mom when she was home. I remembered to lock our apartment door after my mother had gone to bed to help keep us safe, which was especially helpful on a few occasions.

My sister Hayley was born when I was seven, and I had to spend a great deal of time taking care of her. My mom was either absent, asleep, or not in the mood to care for a baby. Often, I woke with her in the middle of the night to give her a warm bottle of formula, which quickly turned into chocolate milk in her toddler years—a habit my mom started that we couldn't break. Changing diapers and washing laundry was never anything I wanted to do but always ended up getting

stuck with. I loved hanging out with Hayley. I even enjoyed tormenting her with scary movies and stories. After all, what are sisters for?

To make matters worse, my mom went to prison for drug charges when I was thirteen and the only options for me were to live with my grandparents or become a ward of the state. My grandparents were gracious enough to take me in. I was a hardheaded teenager who was always trying to get her way. I butted heads with my grandparents constantly. However, I decided to work two jobs after school all through high school to avoid the fights with them and make money for the extras they wouldn't help with.

Jump to the young age of twenty-three. I'm in the middle of a divorce with a two-year-old son, and I (again) stepped up to finish raising my sister when our mother wasn't allowed to do so. I was always adding stressful things to my plate. It seemed like everything I did was the hard way. Lessons didn't come easy for me and change was a constant. I had to learn to adapt to a variety of situations and quickly learn to go with the flow. Perhaps that's why I'm always up for something new and challenging.

When I was able to start earning money, I applied the same concepts from my personal life to my professional life: always be up for something new and challenging and ready to learn anything. I'd been witness to how money could tear families apart and how it could do some great things as well. I didn't have a good relationship with money for many years, nor did I understand the concept of saving any. My appetite for money was unhealthy. I used it to buy friendships and made short-sighted purchases that only set me back further. It wasn't until I hit my thirties that my attitude toward money started to shift to a more positive light.

As I grew up, I saw people lose their jobs, become disabled or terminally ill, and have many things out of their control stop their flow of money. I worked for employers who valued their employees' work until they didn't want or no longer had a need for their skills. This is why I became uncomfortable with just one income stream. When I didn't have multiple revenue streams, I was anxious or nervous that I had no control of my future. No matter what, though, I always wanted to be happy while earning money. I wanted to use it for good and help people grow.

Over the last seven years, it has become apparent to me that my thoughts about earning money vary greatly from many other people. I often find myself in a debate with others about how I should be going hard and fast at one thing only and that spreading myself too thin or burning the candle at both ends isn't a healthy way to live or a smart way to earn money. I disagree completely. I believe in having many things going at the same time but that they should also complement each other. I also believe these things should reflect what you are most passionate about.

For instance, in 2016, my passion for the printing industry led me to purchase Edge Magazine, a West Omaha, Nebraska print magazine. In 2019, I started another Omaha-based publication, Dine Magazine. My goal is to share stories through print, give people a reason to put down a device, and get lost in a tangible print product. Today's news is tomorrow's history. Why not capture it in a beautifully printed community magazine?

One specific focus over the last four years has been figuring out how to create revenue while not actually being present—AKA passive income. At various jobs, I watched

and learned from my employers about building a brand that creates constant revenue. I became obsessed with it. I wanted another row of seeds in my garden.

In 2017, the idea of building a brand of consumable products that left a feeling of empowerment and encouragement became a reality. A year later in 2018, Clout Coffee launched with a mission to put more Clout in everyone's cup. To me, coffee is so much more than our morning routine (or if you're like me, an all-day routine). A cup of coffee is often enjoyed over an intimate conversation, business talks, or in our lone moments while we plan our dreams and awaken to a new delightful day.

The much larger life goal is to generate enough seed money to help build up children that come from similar situations that I went through, as well as to share more power and strength with everyone. Money is just one tool in our toolbox. Being able to provide the right seed money to the right person can have an amazing impact on the performance of their garden.

I've been fortunate to have mentors and previous employers who helped shape this portfolio mindset. Their portfolio of business investments was not just in the stock market. Complementary businesses that fed into each other and helped each other grow and thrive were always of interest to me. Referring back to our garden analogy, these are companion seeds: growing a garden of complementary and companion businesses that help each other thrive.

I'm thankful to the people who've disagreed or pissed me off. They have fueled my passion further. When people give you advice, it is from their perspective, not yours. Don't lose sight of that. Keep learning, growing, and planting. Take advice and criticism with a grain of salt.

As I write this book, our world is enduring the coronavirus pandemic. Tens of millions of people are unemployed, scared, and curious about what their future holds. Many are fortunate to work from home and are still receiving a paycheck. With that said, I'd also bet those working from home are also nervous about their futures. Our government has issued stimulus monies, and some small businesses have been eligible for disaster relief funds and paycheck protection programs. I and many other small business owners are nervous about the future financial impact this will have. Thankfully, I am less nervous because I can see the other rows in the garden still growing like they should. I am also working to plant more rows in the very near future.

I wanted to share this book with the idea of helping the next person up the ladder. If you find yourself hungry for more, needing encouragement, or are seeking opportunities and growth, then this book is for you. You are capable of so much more. Don't lose sight of your larger goals. Learn to jump over, duck under, and work your way around any obstacle that life throws at you. My hope is that my story inspires you to look beyond your current situation, chase your passion and purpose, and grow your garden as you see fit.

Whether we want to admit it or not, we will come out of this changed. COVID-19 is only one obstacle, and yet it doesn't have to be. Our mindset is self-controlled, and what we consume is our choice. In this book, I will share my stories of adversity, failure, and success. My hope is that I can help you realize your passion and encourage you to chase it like your life depends on it—because it does. Remember, you get

one shot at life. Now is the time to overcome, think outside the box, and grow stronger.

I overcame a few obstacles. I dodged a few bullets. Many people thought I wouldn't and shouldn't amount to much. But I grew. And you can too.

Get rid of your doubt and replace it with Clout.

CHAPTER 1

JUST ME AND MY MOM

─────

As far back as my memory takes me, my mom Teresa and I lived alone in an apartment in Osage, Kansas. I would have been about five years old when memories really started sticking with me.

Some mornings it was still very dark when we'd be walking down the long sidewalks to the car. My mom was always in all-white clothing, and I knew she worked in a nursing home and that she loved it. She must've worked an early shift because I would go to a babysitter to go back to sleep before waking for breakfast. Some mornings, I stayed home alone while she went to work so I could watch for the van that took me to preschool. Thanks to all of this, I learned how to tell time early.

I looked forward to the phone calls with my grandparents, who lived in Nebraska. Prior to all phone calls, my mom would remind me that what went on in our house was our business and that I need to keep my mouth shut. If my conversations veered in the wrong direction according to her, I'd get the look that usually preceded a spanking that always left my rear sore and bruised. My mom had a short temper with me, so I was always trying to do things to keep

her happy. Keeping conversations short and positive with my grandparents kept me out of trouble. I always wanted to put her in the best light even though she was a completely different person behind closed doors.

Sometimes my mom would give me some change or a dollar and I would walk a few blocks away to buy a Chick-O-Stick candy bar and bubble gum at the nearby small convenience store. The lady that worked most of the time had long dark hair and she helped me add everything up to make sure I had enough money.

At home, I would stand on a chair to make mom peanut butter toast and help wash the dishes. I often gave her coupons for free back rubs from me. I would get all kinds of lotions and sometimes the pie crust roller to give her the best massage in town. I was always trying to keep her happy with me, which I thought would keep me out of trouble, but my mom still got angry with me quickly. And when she did, it hurt for days and often left bruises on my arms and bottom.

My gramma, Carol, who I called mema in my younger years, was always bringing me nice clothing and taking me to do fun things when I visited her. She was the best cook around. She had her own cleaning business in Omaha and always had a car full of cleaning supplies and mini vacuums.

Anytime my gramma, mom, and I were together in public, it was no secret that we were family. We all had blonde hair and blue eyes. My gramma was pretty petite in size because I don't think she ever sat still. If she wasn't cleaning something, she was cooking up a storm or out messing in her garden. She'd often carry a cigarette and a cup of coffee. Her coffee was usually in a clear glass mug and always straight black. My mom drank a cream-colored coffee with flavored

creamers. Mom's coffee smelled and sometimes tasted better than gramma's.

I looked up to my gramma. She never raised a hand to me the way my mom did. I always thought that was because she was a gramma.

My grandpa, Bud, was a little intimidating on the outside. His high and tight haircut, tattoos, and stocky size made him seem tough. To me, he was a teddy bear that made me feel safe. To everyone else, he was a strict law enforcement officer and proud veteran. I looked up to him too. He would always show me his badge and guns and talk about "catching the bad guys." He would explain to me how to be safe and when to question situations. He would often ask me about situations at home, but knowing what my mom would do, I kept quiet. He was always challenging me to learn more and read as many books as I could. He was my favorite nap partner, too, because I could lay my head on his big belly. We were also fishing buddies.

I used to spend some weekends with my dad, Richard, but that ended at a really young age. My mom said it was in my best interest. I knew my mom didn't like his girlfriend, and honestly, I didn't like her either. She made the movie Cinderella come to life. She was always favored her own kids and everything I did was wrong and punishable. Though my mom was hard on me, I never felt like I was compared to anyone else.

Some evenings, my mom went out with friends and left me alone in the apartment. She would always tell me to lock the door and not to fear anything. I was also not supposed to tell anyone that I was ever home alone. Sometimes, she even got me some pizza and snacks or a VHS tape of my choice.

One evening, when I was about six years old and home alone, there was knocking at the door while I was asleep in bed. It startled me because it seemed quite late for anyone to be coming over. I looked at the clock and saw that it was past midnight. Scared, I cautiously went to the door. Being extra quiet, I crept over to the window near the door and peeked out the blinds. There were two officers at the door.

Thankfully, I had locked our door before I went to bed. These officers seemed persistent and even knew my name. They were asking me to open the door. I still didn't trust them, and remembering the things my grandpa Bud taught me, I asked them to show me their badge through the peephole. After an interrogation, I trusted they were telling the truth, so I opened the door.

I don't recall much more than being taken over to my babysitter's house. I figured my mom went to jail that night but wasn't sure what happened. When I saw her the next day and asked her about it, she said it was none of my business and I better keep my mouth shut about it. Just like everything else, I complied. I didn't know any different, nor did I have anything to compare my situations to.

CHAPTER 2

MY MOM GOT A NEW LAST NAME

When I was about six years old, a man named Billy started coming around. I liked him. He did a great job of taking my mom's attention away from always looking for reasons to scream at me and spank me. We ended up moving into his home in Lyndon, Kansas, just a short drive away.

Billy had a daughter named Jessica who was just a couple years older than I was, and she would come to stay with us every other weekend. She lived about an hour away from us with her mom. My mom and Billy sometimes fought about her. It was usually about how Billy was the one doing all of the transportation. Sometimes, my mom would tell him how much more he spoiled Jessica than me. Once in a while, I could ride with Billy to go get her. It was a great bonding time that we didn't get a lot of. We would often stop at a gas station and I would have to get a cold packaged sandwich to eat. They were terrible, but I managed to choke them down.

Jessica and I became great friends. I looked forward to her visits because it meant that both my mom and Billy were in

a better mood and there was less fighting. We would stay up all night playing cards and board games and talking about everything. We were competitive with each other too. We were the most competitive over outdoor activities like racing to get somewhere first. We were also competitive over the board game Monopoly, which we played a lot of. The funniest was who could eat a Banquet TV dinner the fastest. I had my time in just shy of a minute.

Things were going great between my mom and Billy. They went to the courthouse and got married. Mom's last name changed and mine stayed the same. I felt left out and didn't understand, though I was happy for my mom. She seemed much happier.

It wasn't long though before the fighting started. They had always bickered, but something changed, and the fights became physical. I never really understood what triggered them, but it was usually when both of them had too much alcohol to drink. The yelling would start then the pushing, shoving, punching, and kicking would set in. My mom was drinking more than before and started acting weird with her sleeping habits and mood swings. Things were thrown around the house, glass was broken, and bruises were a constant on her arms. The physical portion of the fights usually stayed between them, which meant I didn't get spanked the way I had before. I tried to stick up for my mom on occasion thinking that Billy was the bad guy. That never worked out well for me, so I learned to keep my distance. When I got involved, I got blamed.

When Jessica was there, they rarely even argued. I'm pretty sure they didn't want her telling her mom or even the rest of Billy's family that lived locally. No one really knew much outside of our home. I wanted to be close to Billy but

was also scared of him. Though his anger toward me was mostly directed at my mother's actions, I didn't think he loved me. I remembered waiting around the corner from the living room many nights and counting to ten over and over trying to encourage myself to go hug him goodnight. Some nights I would gain the courage and on other nights I went back to bed without a hug goodnight. I don't recall ever asking my mom for a hug goodnight.

Billy had a large family that lived nearby. I finally gained cousins and had other kids to play with. We all went camping, hung out at each other's houses, hunted crawdads after a heavy rain, and shared stories about the Ghost of Salt Creek. He was believed to be a headless man on a horse that had died, but his ghost remained by Salt Creek, which was right down a dirt road from my house. No one was sure if he was real or not, but I erred on the side of caution because anything is possible.

I looked forward to summertime. I stayed up late, slept in, and spent time at the beach at Melvern Lake or Pomona Lake. I'm fair skinned so the sun has always been my nemesis. It didn't seem to matter how much sunscreen I wore, I burned. One of the first hot summer days in 1991 when I was seven years old, I decided to go to the beach with my cousins and their mom. We swung by Casey's General Store where my mom was working to grab some drinks and snacks and go spend the day swimming.

At the beach, the sand was hot under my feet, so I ran to the water. Soon, we were splashing and exploring around in the water. I had a couple years of swimming lessons, so of

course, I knew it all. My cousin John and I got into a water fight splashing water towards each other's face. That caused me to back up to deeper waters. Soon, I was treading water and trying to splash back. I became fatigued and told him I didn't want to play anymore. He swam away.

I found myself unable to touch the bottom anymore and kept going under the water trying to swim to the shallow side. Nothing I did was getting me closer to shore. I kept bobbing in the water and swallowing more water each time. I was flailing around enough to catch the attention of a young, brown-haired girl on the beach who came and pulled me to the shore. I was exhausted and full of all the water I had swallowed. I remained on the beach until it was time to leave. I was exhausted and embarrassed. How could a girl who had a couple years of swimming lessons nearly drown? Thankfully, no one else saw it.

In the car, John ate all the snacks as I sat in the backseat, yearning for crackers or something to try to soak up the water. I was starving but still felt so waterlogged. As I sat back there reflecting on what almost happened to me, I became grateful for what I have and scared I almost lost it.

When we pulled into Casey's parking lot, I ran in and gave my mom the biggest hug ever. She was in a sea foam green jumpsuit that barely fit her large pregnant belly. I looked at her belly and realized that soon it was going to be more than just me in that house. This baby was going to need me. It was the first time I looked at my mom's belly with responsibility. I couldn't be upset about the beach anymore, but I needed more swimming lessons for sure.

CHAPTER 3

VISITING MY GRANDPARENTS IN NEBRASKA AND COMING HOME TO A SISTER

The best part about summer was going to see my grandparents in Nebraska. It was at least two weeks of freedom away from my mom. This particular year though, I had to stay longer. I was going to have a brother or sister, and my mom wanted to rest more. Having a rambunctious seven-year-old like me must've been hard. I didn't care though. I gathered my books, as I'm a huge *Goosebumps* fan, packed my clothes, got some snacks together, and was ready for the seven-hour drive. My grandma always got me Cheez-its and grapes for the ride to help with car sickness. I made sure my mom got these things for the ride up. This time, my grandpa Bud was coming to pick me up since the ride is a bit risky for my mom who was very pregnant.

After the beach incident, I was ready to get out of there. I saw my grandpa pull in and I ran to meet him. He barely stopped the car by the time I opened the door for a long-awaited hug. He greeted me with a big smile and an equally tight hug. It felt so great to wrap my arms around him. I loved the smell of his clean clothing. He always wore a white t-shirt under another shirt, and I looked forward to when I could help my gramma wash white clothes and fold his t-shirts. The smell was clean, calming, and consistent.

His red Bronco hadn't even cooled, and I was already packed and ready to go. My mom insisted on feeding him and having him rest a bit. He never makes a round trip all in one day, but I knew we would be headed to my great grandparent's house just a few minutes away.

It seemed like forever when we finally left. After traveling a few miles down the highway, we turned down the long winding driveway and an A-frame stone house came into sight. I've always wondered how great grandpa Frank built this house himself. I loved everything about that acreage, like the horses, the fishing pond, room to roam, and the long dining room table. There was even a huge hollowed out tree trunk full of beautiful colored flowers all over it on display in the front yard.

My gramma Carol's dad, great grandpa Frank, is a cool guy that I feel we would see as often as the grandparents that live seven hours away. Great grandpa Frank wore so much denim, from blue jeans and denim shirts to denim overalls. Only once in a while did I see him in plaid shirts. The lines in his face ran deep, but his eyes and smile were so sincere. He bought me my first wood carving and wood burning kits. I couldn't compete with his talent, though. He could take any stump of wood and turn it into beautiful art.

My great grandma, Suzie, passed away a couple of years prior. She called me Precious and was the sweetest, gentlest lady. I loved looking at her photos and beautiful old jewelry. She grew up in Georgia and made a mean pecan pie. My great grandpa Frank seemed to miss her. He didn't change anything about the house after she passed away. Growing up during the Depression, my great grandma stocked up on many things. Grandpa Frank would sometimes joke that there were things he would never have to buy again. I explored their basement and closets each time I visited because they had so many unique things and great stories to tell about the things I found. I loved having my own room to sleep in with such quirky old quilts on the bed as well.

Many family memories were made in this house. This is where people would gather for the holidays. Sometimes my mom brought us alone, while other times my grandma picked me up and my mom wouldn't come at all. I could never understand why someone wouldn't want to spend all their time here and have this family around every day.

We set our bags down and were encouraged to come have a snack and visit. Sliced summer sausage and cheese were waiting for us on the same dinner plates as always. (To this day, some thirty years later, my husband, boys and I still eat on these plates every day.) I loved the predictability that came with visiting my family. Their lives seemed so normal.

"How are your grades, Carole Sue?" my grandpa inquired.

"I didn't pass last year and need to repeat the grade." After both men nearly choked on their food, I busted out laughing.

"Of course, I passed." I confidently said as I put some cheese on a cracker and began snacking.

It was because of these conversations that I applied myself. I didn't want them to be disappointed in me. My mom had

never been involved in my academics or interests, but my grandpa always asked me, and I didn't want to let him down. He kept telling me that the "only thing that can't be taken from you is your education."

We spent our evening in the living room watching baseball on mute. My grandpa read a book while I ate Butter Brickle ice cream in a sugar cone. Rags, the Boston terrier, always got the bottom of the cone and she knew it. I never understood the purpose of watching the TV on mute much less the point of watching baseball, so I said my goodnight and headed to bed.

I always had trouble falling asleep. If I was not listening to my parents fight, then sometimes my mom would come in my room to cry to me about not being able to pay bills. Some nights I had trouble falling asleep because I was hungry. Billy came home late most nights and would fry up potatoes if there was nothing else, but many nights I went to bed before he got home.

Our house was always one extreme or the other. We either had plenty of food and a good time, or there was anger, fighting, and not much food. I lay there, thankful for the peace. I was anxious to get to Nebraska and fall asleep thinking of all the fun I would get to have. I drifted off to sleep on a fluffy pillow and warmth all around me.

The sun wasn't even up yet when we headed out. After a great night of sleep, I was ready to hit the road. Later in the morning, I saw the Nebraska state sign approaching. I knew what was coming. "Your IQ just went up ten points, sister.

Welcome to the good life." He was always teasing me about being from Kansas.

I was anxiously waiting to arrive and knew what lay ahead for me: more swimming lessons, which I clearly needed, lots of good meals, trips to the library, staying in Omaha with my grandma, and helping her clean homes and businesses. It was all so fun, and I couldn't wait to get started.

My gramma met us in the driveway. I am named after her and I admire her. She takes care of me from a distance, always sending me books and clothes that she knew matched my style. We headed inside and there were more snacks waiting. There was always food around, which was so comforting. Full meals were scarce at my home and we generally filled up on junk food.

"So," my gramma said. "What shall we do for fun this summer?"

"Swimming, shopping and going to the zoo," I replied almost instantly. "I want to help you clean in Omaha too if that's okay?"

"You can always help your mema out because we can go shopping sooner that way," she said as she smiled.

I was growing out of calling her mema and I could tell she missed it. Part of me felt like it was childish.

"How is your mom doing?" she inquired.

"She's a total bitch." I replied. "Pregnancy hormones must be a real thing," I exclaimed. I was reminded that language like that wasn't allowed. She knew where my mouth comes from. Besides, it was the truth. Enough about her. We had things to do.

There was always a dented brass tin that they collected pennies in throughout the year. Those pennies were for me to take to the bank, and I got to keep the money and spend

it on whatever I wanted. If I wanted to go to Omaha with my grandma and help her clean, I could make more money. I always wanted to do this because it meant that my gramma and I would go shopping and eat out often too.

The first couple weeks, I stayed with my grandpa during the week while my gramma cleaned in Omaha. I swam most mornings, paying extra attention in the deep waters. In the afternoons, my grandpa would sometimes let me ride in his cop car to the sheriff's office where I would hang out with the dispatchers and snoop around trying to find out information on the "bad guys."

When my swimming lessons were up, my gramma let me come to stay with her in Omaha and help her clean. This was extra exciting for me because she let me go through the green and white thick coupon book to find some things we could do on discount. If we weren't cleaning, we went shopping and out to eat at sit down restaurants.

On one particular afternoon, we were in Omaha cleaning the commercial office PIP Marketing Signs and Print. I loved walking around that office looking at all of the printers and copy machines. The smell of the paper and ink was amazing to me. However, vacuuming up all of the little pieces of paper was my least favorite part. My gramma's cell phone rang, and she excitedly announced that my mom had the baby!

"It's a girl!" My gramma exclaimed.

I was a big sister to Hayley. I was so excited! Everyone was doing well, too. It was then that I was ready to go home. I enjoyed my trips and usually never wanted them to end, but I couldn't wait to meet my sister. We waited for the weekend and went back. This time, my gramma took me so she could also meet Hayley.

WHAT HAPPENS IN THIS HOUSE, STAYS IN THIS HOUSE

———

For a while, my mom and stepdad seemed happy with our new family. Everyone was getting along, and my mom seemed like she enjoyed having a new baby. My sister was so cute. She had dark hair and dark eyes. Very different from me, but she took more after Billy than my mom. My sister got to sleep in my parents' room, and as colder weather approached, we huddled around the wood burning stove in the living room more often, which was nice.

We had two yellow cats that were brothers named Bruiser and Garfield. If I wasn't playing with my sister, I was outside finding adventures with my cats. I loved our area in town. We were on the far southwest corner of town. We had a corn field behind us, and the neighbors across the street had chickens and horses that I would sometimes go visit. Their home was on the way to Salt Creek. I was always really nice to the

neighbor's horses in case the Ghost of Salt Creek from the old local legend kept his horse there.

I enjoyed taking care of my mom and my sister. My mom even let me help make Hayley's bottles. It was late October before Billy's family came over for a cookout. We had a ton of fun with food, pop, catching lightning bugs, and exploring down around the ravine. Then, I noticed that the adults were getting drunk. This never ended up well.

When everyone else left, my mom and Billy had a huge fight. Hayley lay in her car seat screaming, and my mom had a kitchen knife out threatening Billy. Cactus plants were thrown across the house. Glass dishes lie broken everywhere. At one point, he was crouched over her, slamming her head into the washing machine. She was bleeding. I couldn't control my emotions anymore and as I cried, I begged him to stop.

"Get the fuck out of here." He snapped back at me.

I ran to Hayley and tried to console her. Nothing helped. She was so upset. As I cried, I rocked her car seat and tried calming her down. I was shaking myself but wanted to be strong for her.

The fight carried on into the bathroom. My mom screamed my name. When I arrived at the door, Billy was holding her head under the running water in the bathtub. She yelled for me to call the cops. I turned and went to grab the cordless phone. Just as I picked it up, Billy was behind me and jerked the phone from my hand. He immediately threw it against the wall, shattering it.

He got face to face with me and yelled, "Get the fuck out of this house now!" Scared, I left.

It was dark out. I didn't know where to go. I was trembling and so upset I could hardly catch my breath. I sat on the front

porch not wanting to be too far away from Hayley. I thought that since he loved her so he wouldn't hurt her. But why didn't he love me? Why is it like this? Is this normal? I realized as I sat there and started to calm down, that I had wet my pants. I went around to the back of the house where my room was and quietly opened my window and climbed in. I changed clothes and crawled on the top bunk where Jessica used to sleep and figured no one would find me there.

I woke the next morning and realized I needed to get to school. I was exhausted. Looking out the window, I saw that Billy's car was gone, so he must have gone to work. I peeked in my mom's room and saw her sleeping. Hayley was in the bassinet next to her.

I grabbed a hot dog, ran out the door, and went to school. I couldn't concentrate and felt my eyes welling up with tears often as the night before kept rerunning through my head. My third-grade teacher Mrs. Payne, noticing that something wasn't right, sent me to the counselor's office. As I sat there, I shared everything. It felt so good to get it off my chest. I was assured that everything would be okay. I felt so much better having someone to talk to.

As I walked home, I wondered how exactly everything would be okay. When I walked into the house, my mom was sitting at the table smoking a cigarette. She had already started drinking alcohol for the day.

"I thought I told you what happened in this house, stayed in this house?" She scowled. I felt myself wetting my pants again.

As she grabbed me, I pleaded with her, explaining that I was trying to help us. It was useless. She spanked me over and over. If it weren't for Hayley crying, I'm not sure she would have stopped. When Billy got home, I got the belt. I learned

for certain that night that what happens in the house, stays in the house. How could my school and counselor do this to me? Was it normal to have a home like this? Maybe it really was my fault. If the school, being a place I could trust, felt the need to call my mom, perhaps, I was the one responsible for the fights.

I learned to lay low and keep my mouth shut. As Hayley began crawling and learning to eat new foods, I decided to focus on her more.

There wasn't a bedroom for Hayley in our home. The plan was to put a trailer on the property and tear down the old house we lived in. I remember being happy when the trailer showed up. It was brand new and there was more space for everyone. I thought this would make my mom happier and that the fighting would stop. The trailer even came with all new appliances and new couches. My mom's bathroom had a corner bathtub that I felt I could swim laps in.

Jessica and I still shared the largest of the two rooms, but Hayley got her own room. There was a chair and crib in her room. Because our rooms were on the same end of the trailer, and my mom and Billy were on the other end, I ended up giving Haley a bottle if she woke. I loved taking care of her. As I would hold her, she'd look in my eyes with love.

The fighting didn't stop. I learned to focus my attention on trying to keep Hayley occupied so it didn't upset her. This also kept me from getting involved or upset. Strange people were always coming over and usually carrying bags that they would put things in or take things out of.

One evening, a man and Billy were in the living room. They were smoking pot, and as I walked by, they were acting goofy. I wanted to mess with them a bit, so I got my purple yarn and crawled out to the living room. I tied the yarn onto the black rocking chair with orange and green floral print and crawled back to the hallway. I started to tug on the yarn, which made the rocking chair start rocking.

The men carried on about ghosts in the room and such. I laughed and laughed. It felt good to get along and be funny. It was rare to laugh so much and it always felt great.

I was nearing the end of my third-grade school year and was sitting on our already smelly and stained tan, pink, and blue couch watching TV after school. *Roseanne*, *Family Matters* and *Full House* were my favorite shows to watch. I kept track of the printed *TV Guide* and based my TV watching around it.

It was normal for me to be home alone after school and turning to the television for entertainment. My parents always arrived sometime around dinner or after, not that it mattered since I usually made a Totino's Pizza to eat while I watched TV.

One day, while watching TV, I heard the sound of a car door shutting coming from our driveway. It would be odd timing for anybody to be coming home this early.

I looked out the window. A beat-up old car I didn't recognize was in the driveway and a grungy man was approaching the house. He had dark slick hair and a plaid dark blue shirt on, and he looked upset. I felt like I had seen him before, but I wasn't quite sure.

He knocked on the door. I didn't feel comfortable answering it. Something about him didn't look friendly. My mom had told me not to answer the door for people I didn't know. But he stayed very persistent and began beating on the door. This made me more uncomfortable, and I began to scan the room for a quick escape.

I noticed the door lock starting to come loose, and the door was shaking more. I got scared and thought that he was definitely coming in the house one way or another. I saw our hutch against the wall and thought I could fit underneath. I ran over, crawled underneath the wooden and glass hutch, and knew I needed to stay very quiet. My heart was beating so hard and my breathing was heavy. I did my best to stay quiet.

I used to stand in front of this hutch and admire the antiques that my stepdad would find while working. I was always told to stand back and not touch. Today that didn't matter though. As fast as that door swung open, I was barely situated under it in time.

Hiding like this reminded me of the time about four years prior when it was just me and my mom in that apartment. I always wanted to sleep in her bed with her. I felt safer there. Occasionally, she had let me. I recall a night when she didn't, and I was persistent. So, I told her I was going to my bed and instead went to hers and lay very still and quiet across her bed under the pillows until she came in. When she laid down, I popped up, nearly giving her a heart attack. She ended up letting me sleep with her.

I snapped back to reality when I heard the banging around of furniture. I watched the man go through everything in our house from drawers to cupboards. There was not a table that he didn't go through. He was persistently

looking for something. I figured it was drugs. That's what all the strangers came to our house for. He fit the description of everyone else that came around. As he walked by the hutch, I was half tempted to grab his ankle and come out swinging, but I stayed against the wall. I felt like a coward.

As I lay there, I figured if he didn't see me, I would be okay. I stayed as close to the wall as I could get. Eventually, he left. He hadn't seen me at all, which was good.

After he left, I crawled out from underneath the hutch and gazed at the mess. It looked as if a tornado had gone through our home. This wasn't the first time that our house had looked like this, this was just the first time I happened to be home during the process. Realizing what had just taken place, tears began to fall. Why did this just happen? I always felt myself asking these kinds of questions. As I started putting things away, I thought, "Why do drugs do this to our family? I wonder when something good will come." I didn't tell my mom or stepdad. I thought they would have already known anyway, and I didn't want to cause another fight. That night I cried myself to sleep.

Outside of the incident with the counselor, school was fun for me. I had just started fourth grade and was loving it. I loved my teachers and excelled at every subject. I looked forward to every day I could go to school. I knew my grandpa would be asking, so I always worked to impress him.

My friend Jacques lived in a trailer near mine that was on the way to school. He was a little taller than me with sandy blonde hair and darker blue eyes. He usually brought a quarter, and we'd stop at the same Casey's my mom worked

at to get a box of either Jaw Breakers or Lemon Heads that cost just twenty-five cents. We would eat the candy on the way to school and make small talk. He had a wooden paddle board hanging in his room, and all I knew about it was that when he was bad, he had to take it to his dad. I never asked much more because I assumed the same "what happens in this house stays in this house" applied to him.

Jacques always brought his lunch, and every day I exclaimed at his ability to eat the entire apple.

"That's just gross," I said. "You're not supposed to eat the core."

He dipped it in his thermos of Kool-Aid and replied, "It tastes better with Kool-Aid."

While we ate, we'd discuss our plans for the weekend.

"You coming over for baseball tomorrow?" he asked.

"Sure." I didn't even have to ask my parents to know the answer to that. They never seemed to care where I was as long as I wasn't bothering them.

The last school bell rang for the day. We all ran out as if the building were on fire. It was Friday and my friend Shari was on her way to town to stay with her dad and stepmom, who was Billy's sister, Annette, for her weekend visitation. Shari was my best friend and I wished she lived closer, but we packed as much time into our weekends as possible.

I dragged myself through another disgusting dinner, wishing my stepsister were here to bribe to eat it. I've given up cassette tapes and even my New Kids on The Block sleeping bag over gross dinners like this. I hated tuna noodle casserole. What was worse was getting a slice of margarine covered bread to go with it. I should have been thankful. It was rare to have a dinner with more than one thing on a plate.

The phone rang and it was Shari. She was finally here! She wanted to go to the local bar and shoot pool. My mom was okay with me hanging out at the bar. She would often take me with her. I had grown fond of pickled eggs, saltine crackers, and Shirley Temples. I would shoot pool or play Pac-Man with all of the quarters I could get my hands on. I scarfed down my casserole and bolted out the door.

I hopped on my pink and white banana seat bike and rode to the local bar where I met Shari. We gave each other a hug as if we hadn't seen each other in forever when really, it's only been a couple of weeks. We ordered our Shirley Temples, filled up the jukebox with quarters, and started shooting pool. Her brother and sisters showed up and we kept the fun going. The bar was smokey and full of adults. We were the only kids there. Shari's brother and sisters were much older and in high school. It appeared they were there to keep us "kids" under control.

We were into a good game of pool when this man walked over and put his hand on top of my head. He said, "You must be Teresa's little girl." He was clearly very intoxicated. He could hardly stand up without swaying, and his eyes couldn't focus on me.

I looked at him with my little smart mouth and said, "That's for me to know and you to find out."

I was a showoff. I suppose lack of attention at home had me seeking it in other places.

He continued to put his hands through my hair.

"I'm not an animal, stop it." I shouted to him.

He sneered at me and walked away.

Meanwhile, we all kept laughing, shooting pool, and listening to music. By the time we wrapped up for the night, it was dark and late, and I had to ride my bike home. So,

I hopped on my bike and started heading down the road when a chill came over me. A very eerie chill. I began to get nervous. It felt like somebody was watching me, and I got goosebumps all over my body, making the hair on my arms stand up. I started riding faster.

I put my bike in the garage, ran to the house, and got inside. Feeling a bit at ease, I made myself some popcorn and turned on the television. The only thing on TV this late is *Married with Children*. I was watching the show and eating my popcorn when I heard something at the door. I looked over and saw that the door was not locked so I got up and locked the door.

I sat back down to continue watching television until I could barely keep my eyes open and decided to head to bed. I heard knocking at the same door I had locked not too long before. The knocks got louder and more forceful. I became still, worrying that if I moved at all, I would be found, especially since my bedroom is closest to the door.

They will hear me. They will find me.

Somewhere in me I pulled up the strength to get on my hands and knees and crawl past the door to my parents' room.

"Wake up, wake up," I whispered to Billy as I shook his arm and insisted he wake up.

"Someone is trying to get in our front door. I locked it earlier," I said.

He grabbed a gun, flipped on the lights and went to the front door. After looking out the peephole, he opened the door. No one was there.

"You must have heard something. I'm going back to bed. You shouldn't be up this late anyway," he grumbled as he walked back to his bedroom.

The next morning, the front door, which was a type of aluminum door, had dent marks all over it from the person trying to break in last night. I heard my parents talking about it and discussing who it might have been. My mom asked me about where I was the night before and who I spoke to. I told her I went to shoot pool with Shari and her brother and sisters. I recalled the man that kept petting my head and let them know, but I never got his name.

Later that morning, while exploring the yard, I kept thinking about what that man must've wanted from me or our family. Why did he follow me and how did he know who my mom was? Then, I remembered I had a baseball game with Jacques. I grabbed my things and took off to his place.

There was a ravine between our houses and a rusty pipe that acted as a bridge. I had become a master at running across the pipe, even when there was water flowing deep underneath. Running across that pipe always made me feel like I could conquer anything. I recalled when I had to sit and scoot across, but now, I could run with no fear.

I arrived at Jacques' trailer house and we immediately took off to play baseball.

"What did you do last night?" Jacques asked while we grabbed a quick water break.

"I saw Shari, and we met at the tavern for Shirley Temples and a few games of pool." I explained. I didn't want to relive that moment from last night. After all, w*hat happens in this house, stays in this house.*

The rest of the summer was spent playing outdoors, goofing off, and hanging out with friends.

As fifth grade got underway, I enjoyed the start of fall. It was and still is my favorite season. The crisp warm smell and orange, maroon, and deep yellow colors are wonderful. It was about an eight block walk home from school and I enjoyed it most of the time. It gave me time to think and dream. The fall weather is the best walking weather. I dreamed of what I would be when I got older, and I also dreamed about what I didn't want to be. Thankful for the example my grandparents set, I wanted to have their lifestyle. I wanted nice things and a clean house with lots of space to spread out.

Our trailer was usually dirty, so much so that I'd been treated for scabies, ringworm, lice, and fleas over the years. We always had random flea ridden dogs my mom would bring home. They never lasted long before being dumped somewhere or given to a friend. My two cats Bruiser and Garfield stuck around.

To explain just how dirty things were, a few years before this, I was making fun of the maggots in our house by calling them "walking rice" to my grandmother's friends. My mom had left garbage under the sink a bit too long, causing them to breed. I was later told by gramma that "we don't talk about those kinds of things." I didn't know it wasn't table talk, and for me, sarcasm and being a comedian helped me handle the things I knew weren't quite right.

One fall day, having walked home from school, I saw our trailer was gone—literally gone. How does your home just disappear? Apparently, it wasn't being paid for, so the company came and took it back. I saw my mom over by our garage moving stuff around. She saw me and came walking over. She said we would be moving but were going to be staying a few nights in our garage.

"All of us? On the dirt floor? With no door?" I questioned.

"It will be like a camping trip. We will make it fun." She said.

Wow—nothing about that seemed fun to me.

"Where's my stuff? How are we supposed to go to the bathroom? How will we eat?" My mom had a "fun" response to everything.

"You can go to the neighbors to use the bathroom and I have most of your things in the garage. Pizza for supper." How embarrassing. What would my friends think? How are we all going to fit in this dirty, old rickety garage? I wondered if my stepdad knew. What would he think?

He busted his ass at work, day after day. He's gone before the sun comes up and home late most evenings. He always seems to be quite dirty and exhausted when he gets home. I knew he worked for Burlington Northern Santa Fe and did something with railroad tracks, though I was never too sure what exactly he did. I admired his work ethic, though.

Each summer, various other railroads would compete in Topeka during Railroad Days and his team always won. I loved watching how fast they could build tracks. Billy had several gold-plated spikes and tools that symbolized trophies. What was even better were the free passes to Worlds of Fun and Oceans of Fun for the family. Those trips always started out fun and most often ended with my mom and Billy arguing on the way home, which usually turned into a physical fight by bedtime. I always hoped things would be different. Despite the violent relationship with my mother, he was the one that did his best to keep my mom stable. He reminded me often that if it weren't for him, she would've kept hitting and hurting me.

I wondered if Billy knew that our home was gone and what kind of fight this was going to start. I took off to

our neighbor Edith's house for a game of War and some fresh-popped popcorn. I loved this old lady. She had short, curly, gray hair and black rimmed glasses and always wore long dresses.

I dropped by to see her often. I'd usually catch her sleeping in her chair but could see her through the window. To be funny, I'd always pound on the glass to wake her suddenly. She would jump, spot me, then smile. I couldn't believe she was born in 1900! Her husband passed away some years before and her children were never around. I thought everyone forgot about her—except me. I loved her.

Her popcorn was the best. She and I would play cards for hours then I'd snoop through all of her books, magazines, and old people stuff. She kept a bowl of water in the bathroom sink that you had to use to wash your hands in. I could never understand why we didn't turn the water on and do this, but this was a rule in her house and I always had to wash my hands when I came over.

"If you didn't notice, our house is gone." I shared.

"I saw that. I heard the commotion earlier in the day and when I looked out the window, I saw it being pulled away." She said tenderly.

"Mom says we are moving soon. In the meantime, can I hang out here more often?" I asked.

"You sure can, sweetheart." She replied. We continued our card game.

I waited a while after I saw Billy pull in to head home—whatever home was now. He was already drinking a beer, and I couldn't say I blamed him. He was usually a quiet guy. It was my mom and her mouth that started the fights. But he knew how to finish them. They didn't seem to be fighting, but they also weren't friendly with each other either.

I grabbed a slice of pizza and tried to figure out how much stuff I had left. My dresser was still filled with my clothes, and there was a tub of a few of my toys and such. I found my box of books and took one out. *Goosebumps: Night of the Living Dummy.* It seemed fitting so I began reading. Books always took me away to another life. Often, I didn't want them to end.

After a few days of this and telling my friends that "We just got tired of that trailer and besides, we are moving to a bigger and better house," my mom announced that we were moving from Lyndon to Burlington. I thought the name seemed familiar.

"The town with the big water park?" I asked.

"Yep, and near the truck stop with the buffet," she replied. I was cautiously optimistic.

The day we moved in was memorable. This house was so much bigger, and our yard had lots of opportunities for exploration. Though it was only a two-bedroom home, which meant my sister and I would be sharing, I didn't care. It had been quite a while since Jessica had come to stay with us, and it didn't sound like she was going to be coming around anytime soon. My mom gave me and Hayley the master room to share, which meant we had direct access to the only bathroom too.

I had just started sixth grade, and Hayley was starting school as well. This was going to be her first year of school in kindergarten since she missed preschool in Lyndon. I was a bit nervous for her because her school building was separate from mine. I always had to keep an eye out for her since it was hit or miss if our mom did; with Billy at work most of the time, it was up to me to help take care of her.

In Lyndon, there were two schools, and they were across the street from each other. This was different, and I can only assume larger, since there are three schools, and they aren't very close to each other. Knowing that we always make it work and it was just one more thing to figure out, I was eager to get started at school and find new friends.

After our first day at school, I got on the bus to see my sister wearing the most ridiculous outfit: an oversized Nebraska t-shirt, my purple and cream-colored skirt with suspenders, black pantyhose, and red dress shoes.

"Are you kidding me? You left the house today looking like that? You can't sit by me. That's so embarrassing," I said. She only had half days of school and went in the afternoons. When we got home, I asked her why mom let her leave the house looking like this.

"Mom was still sleeping so I got myself ready and went to school," she said.

"How did you know when to leave if mom was sleeping?" I shot back.

"Blue's Clues is over at 10:30 so I knew to go to the bus then," she replied. I was proud.

She was learning to keep track of time. Now, we just needed to work on her wardrobe. We spent the rest of the afternoon playing, planning her wardrobe, and talking about our day at school. We both seemed to be happy with our day.

Days went by. We both made friends, spent our days in school, and played after. I don't think our mom got a job during this time. She was usually gone in the evenings. Some days she was home with the windows open and music playing as she

cleaned and cooked. Not too many days later, she'd be in bed for what seemed to be days at a time. I knew it was the drugs.

I hated drugs. Mom was so unpredictable. When she was down, she was really down. The screaming, yelling, fighting, and breaking of things were worse than before. I found myself wishing she could always have the drug that made her happy. I liked her when she was happy. She was kind to everyone, funny, and thoughtful. Whatever made her this way was the way I always wanted her to be.

At school, I became best friends with Hannah. She didn't know anything about my past and was only focused on now and having fun. Her mom often had snacks for us after school. It was the strangest, coolest feeling to have her mom sitting at the table, eating brownies, and talking about our day with us. Hannah would ask to go to my house sometimes and I would simply tell her that my mom had weird work hours and it wasn't a good time. In the brief times she would meet my mom, she would always tell me how cool she was. I never wanted her to know the truth.

I made several new friends in Burlington. Living in a bigger town meant there were more things to do, too. My friends enjoyed activities that cost money, which wasn't anything I was used to before. I began asking my mom for opportunities to earn money.

I'd do any chore in the house for ten dollars. It meant a night at the movies with my friends, and sometimes the boy I liked, Brad, would come too. I made sure to sit by him. All our friends knew we liked each other, too. After the rough part of winter, we all found our way back to the movies regularly. One night, walking home from the movies, Brad grabbed my hand and we walked through the darkness hand in hand. The feeling rushing through my body was intense.

Our friends did what friends do and started teasing us. Hannah yelled, "kiss her!" As if he was waiting for the cue, Brad kissed me in the middle of the road under a streetlight. The rest of the world disappeared. It was a short, awkward kiss but it seemed to last forever. After we quietly walked away, we went our separate ways home. In the days ahead, it was like the kiss never happened. We didn't talk about it and it never went any further.

The summer months found my sister and I playing in the yard in the sprinkler while my mom and her friends laid on lawn chairs with music and margaritas. I'd hang out with friends into the late hours at the school park until officers would come and remind us that it was curfew. What was a curfew anyway? We'd head home, or sometimes pretend to then end up back at the park. My mom didn't seem to care where we were or when we'd be home. She was gone a lot then too. She had really been slacking on getting groceries and cooking meals. Often, when Billy got home late, the only thing for dinner was to make fried potatoes like before.

I ate at friends' houses during the day since we almost never had much to eat at home. Billy seemed increasingly irritated with my mom.

One evening, I saw him fish some cash from an old antique of his.

"Would you go to the store tomorrow and get some things to eat and some milk?" he said. "This is getting ridiculous."

I heard him mumble under his breath.

I was happy to go to the store. When mom got home that evening, he started in on her. It was rare for him to start the fight, but this one was going to be one for the books. I encouraged my sister to go outside and play with me—so to the park we went. I didn't want her to ever experience the

same gut-wrenching feeling of seeing your parents screaming and hurting each other. Plus, if they were really in the moment, sometimes we were in the way and got hurt too.

My mom had a black eye and bruises on her arm the next day, and she stayed in bed. I walked to the store and got some groceries, and even got her a can of chicken noodle soup. I felt bad for her. Sometimes, I hated Billy for doing this. I also hated her for acting this way.

As I walked home with the groceries and her soup, I dreamed of a different life. My friends didn't seem to have the same troubles as my family did. I dreamed of a life with happiness and no fighting or drugs. I was jealous of my friend Hannah whose mom always had a pan of dessert in the kitchen and would get us a plate dished up after school. Why couldn't my mom be like that?

I was looking forward to seventh grade. There were more classes to choose from and the radio broadcasting class seemed interesting to me. To welcome us to seventh grade, a classmate's family had the class over for a bonfire and hot dogs. Many of my classmates' parents also came to the party. My mom never came to anything like this.

When the parents went inside, a game of truth or dare commenced. A cute boy in my class named Josh was dared to kiss me. I didn't know him very well, though I was giddy inside remembering how my first kiss made me feel. Josh had long straight dark hair and dark brown eyes. He was just a little taller than me, and because we didn't have any classes together, he was mysterious.

Trying to act cool and like I'd done this before, I stood up and waited. He came over and planted his lips on mine. When the kiss was over, we stood there staring at each other. A few whistles and screams reminded us that we were not alone. I sat down in shock. He didn't seem fazed at all by this, which led me to believe this was not his first time, or that he was trying to play it out like I did.

The next day my friends encouraged me to see if he wanted to be my boyfriend. I let them call him to ask. After their interrogation, we learned he didn't want to be my boyfriend. Deep down, I was okay with this. Hannah had her boyfriend come to her house and I was not sure I wanted to have anyone over at my house. I avoided my house at all costs with my friends. We could go anywhere else. Hannah was the only friend that came over, and she always said she wished her mom were as laid back and cool as my mom. If she only knew.

CHAPTER 5

MOM WENT TO PRISON AND I MOVED IN WITH MY GRANDPARENTS

———

One winter afternoon in seventh grade, I looked up to see my grandpa at the front of the room. I jumped up and ran to him with a great big hug.

"What are you doing here?" I asked.

He ushered me to the hallway where we could talk in private. His facial expression looked concerned and exhausted. He was in denim jeans and a faded t-shirt. "You are coming to live with us, Carole Sue. Your mom and Billy went to jail this morning and it's going to be awhile before they get out."

I was surprised to see him, but not about her going to jail. I had many questions, and as I started asking them, my grandpa replied with, "Go in the classroom get your things and let's get your locker cleared out." I complied.

"Your sister can't come live with us, so she is going to stay with Billy's mom in Lyndon," my grandpa said. "Billy won't

be in jail as long, but your mom is going to do some time," he said. I was in shock. Sort of.

Part of me had always wanted this, but I sat there completely disappointed. I was finally happy. I had friends and I was doing well in school. I felt like this was a punishment. I was so confused.

My grandpa continued, "We need to make a stop over to your dad's house and get a paper signed."

This was even more confusing. I had only ever heard talk about my dad and vaguely remember him. My only hint of him was a monthly check from social security in my name. His last name was on my birth certificate and my social security card, but that's about all I knew about him. My mom used to take me to his when I was little. That stopped some years before for reasons I wasn't too sure of.

We got home and it was a wreck. It looked just like the times when people scoured our place for money or drugs. Everything had been gone through. I figured it had something to do with drugs and probably them going to jail. My room was a disaster, and all my personal things had been gone through. Maybe the cops did this. I wondered what they found and why my room had anything to do with it.

I couldn't take everything with me, so I had to pick a few of the important things. I grabbed my music, books, and a few toys that had special meaning. I had this little bank called Robie and he would rock back and forth before tipping his hand and eat the coins. I chuckled as I packed Robie; I knew my mom always took any money I had in my room.

"Your grandmother is already getting you new clothes, so don't worry about grabbing those." He tried to cheer me up with that statement, I think. It didn't matter though; I was becoming very sad. I had always dreamed of moving to my

grandparents', but I felt like I was coming into my own here. I had friends and I was excited for my classes.

We pulled into a somewhat familiar driveway soon after we left, and I learned this was where my real father lived. His name was Jim, but everyone in town called him Cooter. He also lived in a run-down trailer like the one I had lived in before it was repossessed. He welcomed us in and acted like we were best friends that had stayed in touch. It was odd.

"Look at these pictures," he said. "I have quite a few of you when you used to come see me." I softened and looked at the photos. I was smiling in them so I assumed it must not have been the nightmare that my mom made it out to be.

My grandpa pulled out a paper and said, "Teresa has been put in jail and her sentencing is going to be lengthy. The best thing for Carole Sue is to come and stay with her grandmother and I in Nebraska. In order for us to take care of Carole permanently, we need your signature on this paper."

My dad replied, "It's about time Teresa gets the help she needs. I knew about the drugs; I just didn't know how bad it had gotten. I agree, Carole should go and stay with you. It would be the best future for her. I am in no position to take her in here."

When it was time to go, my father hugged me. I couldn't recall that ever happening before. In the vehicle, my grandfather explained that he always got along with Jim and said he was just too simple for my wild mom.

We had an overnight stay at great-grandpa Frank's house and then hit the road for Nebraska. I didn't even get to tell my sister goodbye. The emotions running through me made that one of the longest trips. I didn't bother to talk about it. Feelings were never discussed at home anyway.

When we arrived, my grandmother was excited to see me and showed me to my new room. I'd always stayed in the guest room as the other two rooms were for storage, but one had been cleaned out and was ready for me. It was filled with lots of new clothes, too. That evening, we ate a full meal at the table, and we were all fairly quiet. Was I staying for a few weeks? Through the school year? Forever? I had no idea.

"Tomorrow, we will go to the school and get you registered. You will need to be ready by 8," grandpa said.

"Sounds good," I replied. Not wanting to get into too much conversation tonight, I let my questions rest.

<center>***</center>

I remember my first day at my new school. This school was much smaller and older than my previous school. I was nervous about meeting new friends and wondered what I'd say when people asked where my parents were. My grandpa and the principal, who was a nice older gentleman, gave me a tour and introduced me into each of my classrooms before handing me off to my first period English class. I recognized Becca and Kasie from meeting them at the pool the summer before. Seeing familiar faces helped. After first period, there was an announcement over the loudspeaker.

The principal announced, "Everyone, we have a new student starting today. Please welcome Carole Shepard. Today, due to the snow, we will be taking the bus down to the elementary school for lunch." I was mortified. I had hoped to just blend in. I hadn't thought of what to say when people asked me where my parents were yet.

When the lunch hour came, I made my way to the bus. Upon climbing up, I was welcomed and cheered for by all

the upperclassmen. It was odd to me that everyone knew me right away. At a school this small, it was easy to pick out the new kid. I was annoyed.

As the days went on, I made new friends and got to know Becca and Kasie more. Everyone asked about my mom. I decided I wouldn't lie. She was in jail and I was living with my grandparents.

On Valentine's Day, I got a delivery to the school. As I approached the office and saw the balloon within a heart shaped balloon with bars on it symbolizing a jail, I knew it had to be from my mom. For a minute, I had hoped she was out of jail and on her way to come get me. I found myself thinking about this often.

Living with my grandparents, the rules were simple. Anything above the necessities provided to me was on my own dime. I was grateful enough for the space to live and feel safe. I was also used to having to fend for myself.

When summer arrived, my grandpa helped me find employment cleaning shelves and bagging ice at the gas station. He bought me a bike so that I could get there faster than walking with the agreement that I'd pay him back out of my paycheck. I also helped my grandma clean homes and offices in Omaha. Much like learning about earning money to hang out with friends the year before, I was eager to get my own cash and make my own choices.

That summer sort of felt like summers past, but it was no vacation now; I was a contributing member of the home. I was expected to do more chores and not be paid for them. I wasn't treated like the guest I had been before and I was constantly in trouble for being late for curfew, not getting chores done, and slipping grades. My grandparents who were once proud of my every accomplishment were now always on

my case. It didn't matter how hard I tried, nothing seemed good enough. So, I figured "why even bother?" I began to lose interest in everything.

They never wanted to talk about my mom, and it took months for them to take me to see my sister and friends. By the time we did go back, my stepdad was out of jail and had my sister living with him. He was still standoffish with me. My sister didn't want to stop hugging me. They seemed to be doing well, and there was way more food in the house than I remembered before. It was weird to not see my mom. Before, I was ashamed of her and didn't want to be around her. Now, I felt myself missing her and wished she were here. Billy and Hayley seemed to be doing well, and I wondered if maybe I really was the problem before when I lived with them. Feeling like a burden in Nebraska and realizing I might have been one in Kansas as well had me feeling like I would rather be on my own.

The next spring, my friend and classmate Trudy told me about detasseling. I had never been near a corn plant, but apparently, you just pull the tops off of the corn stalk. Supposedly, it paid well and lasted a few weeks. Trudy and I had a lot in common. We both had to work for our money and had home chores assigned to us quite often. She also had a younger sister about Hayley's age that she took care of often, too.

When I told my grandpa about detasseling, he laughed and said, "You won't last one day, sister." I took that as a challenge and signed up.

I didn't even know what a tassel was on my first day. Not only did I have to walk miles and miles in the corn fields, I had to walk to the school each morning in the dark to make it to the bus. It was hard work, but hearing that voice telling me that I wouldn't make it fueled me. Not only did I make it, I received one of the highest bonuses at the end of the season for being so reliable. My grandparents congratulated me by allowing me to purchase all my school clothes. I was happy to buy my own clothes. I had been made to feel like a burden moving in with them, so I tried to pay for as much stuff on my own as I could. This way, I could never be made to feel guilty for the things I had.

I ended up spending three summers detasseling. The girl who hated the heat, bugs, and sweating was out to prove a point. It felt great to prove my grandpa wrong about me.

My gramma and I played rummy on the weekends and it reminded me of playing cards with Edith. During the week, my grandpa and I played Scrabble. That man was always reading books. In fact, we'd drive to Columbus just so he'd have a bigger library to check out books from. In the early days of Scrabble, he would give me a point handicap so I wouldn't lose so bad. All that did was piss me off.

Between games, I took the dictionary and started looking up words, especially words with the letters would have a higher point count. It wasn't long until I not only didn't need a handicap, but I was whipping him in the game. It felt good to beat him at something.

The games and the meals together were great. However, I was such an independent person that my grandparents' micromanaging and hovering over me was hard to overcome. I was looking for an escape from the never-ending

disappointment that I seemed to bring. That leads me to remember the first night I found alcohol.

I was the cop's kid and "probably" a goody two shoes. Not only did I drink more than everyone thought I could, I got drunk. Making my curfew on time, I quickly went to my room so my grandpa wouldn't see me, and I got away with it. That was empowering. I had broken the rules and didn't get caught for once. I knew I could do it again. Plus, drinking was a great way to release the pressure that was always on me to do more and be better. This was the start of a bigger problem for me. Alcohol was something I turned to when life got tough. I did my best to hide it, too.

When my sixteenth birthday rolled around, I was surprised with a car. My grandparents gave me a little ceramic yellow birdhouse figurine that opened. When I opened it, there was a car key inside. After going outside, I was excited to see a black 1993 Mercury Sable in mint condition. It had been my great aunt's car, and she took terrific care of everything she had. The agreement was that I had to pay for the gas and insurance, but the car itself was a gift. That car opened me up to a whole new world. I would gather friends and drive around the square on the weekends. I could also get a job a little out of walking distance and get to work quicker than walking.

I immediately found an after-school job at the local grocery store and ran the numbers to pay my bills. I always wanted more money though, so I found a second after school job. More money meant more stuff and more fun. Those were things my grandparents didn't help me buy, so I learned to buy it on my own.

I worked at a grocery store and in a nursing home. Each month, I'd lay out my calendar and end up with about one

day where I didn't have to work, which usually fell on a school day. Because my car would be taken from me for low grades, I managed to keep up my grades and work along with paying my monthly bills. I often had money left over to buy alcohol, which became a bigger problem by the day.

Working at the local grocery store didn't last very long. I had gotten caught with alcohol in my trunk at school, which caused a whole series of other problems. When I got my car back, the only other option for employment was to work at the grocery store in Stromsburg, which was about a ten-minute drive away. They didn't sell alcohol. My grandparents were doing everything they could to keep me away from it.

I got involved with a boyfriend and became obsessed with going out any night I could after work. Soon, my grades dropped, I drank more, and I was constantly grounded, and felt completely miserable. At some point in all this, my mom got out of jail. My mom, Billy, and my sister rarely came to see us, but my grandma took me down as often as she could so I could see them.

On one trip, my sister brought a shortened red straw to me that had white residue on it, and I knew my mom was back on drugs.

"Are you fucking kidding me?" I mumbled under my breath.

Had she not learned her lesson? I was so angry with her. My sister had no idea what was going on, but that mom was headed down the same road that took me away. It was during that trip that I overheard my mom asking if she could have back the social security checks that came in my name since

it was money from my real dad. My gramma explained that the money was used to care for me so it would continue going to them.

Wow. She wants the money back but didn't ask at all about me coming back. I thought.

At this point, given that I felt like a prisoner in my grandparents' home, I really did want to come back. I was tired of never being good enough and having so much responsibility on my plate. I didn't understand why I needed permission to go out with my friends or why my grandparents didn't like my choice of friends or boyfriend. I missed the freedom that I had at my mom's. I also didn't want to be back in the mess that my mom seemed to be getting back into. I was so confused. I didn't really know what I wanted.

Back at home, finding any excuse and usually lying, I would go out with friends to drink and party. I showed up at Kasie's dad's wedding reception drunk, and it must've been obvious enough for someone to call my grandpa because he showed up. A blood alcohol test at home confirmed that I was three times the legal limit of an adult. My grandpa sat there crying. He sent me to bed. The next morning, I went downstairs and sat across from him at the table. I was scared and nervous.

"When your mom was in high school, I got called out to a dead person in the city park," he began. "It was your mother. Overdosed on drugs and blue. We thought we lost her. And I NEVER want to find you that way." We both cried. I lost my car for several months, which was deserved and not surprising.

His resolution was to send me to therapy. I hated spending my time speaking with this woman in her stale-smelling office. She wanted to talk about how everything made me feel,

and I never wanted to discuss my feelings. Her conclusion to my grandpa after several sessions was that I wasn't loved enough as a child. *Well duh, I thought. What a waste of time.*

My senior year was a blur. I worked as much as I could and partied as hard as I could, all the while counting the days until I could move out. By this time, my boyfriend had left me for another girl. I couldn't say that I blamed him. Sneaking around and having to stay home so much was hard on our relationship.

A lot of my friends were talking about going to college after high school. I hadn't given much thought to it and enrolled at the community college in Columbus, Nebraska. I figured I would move to Columbus and figure it out when I got there.

On the last day of high school, I headed to Columbus to go cruising and hang out with several friends. Columbus was our hot spot. There was so much to do and so many people to hang out with. Plus, it was a great getaway from the small town where everyone knew your business and usually told my grandpa what I was up to.

We pulled up to a car full of guys. We struck up a conversation with them at a stop light and agreed to pull into a parking lot and keep the conversation going. This is where I met Bryan. We became quick friends. Bryan was a little taller than I was, with dark hair and hazel eyes. He was into Ford Mustangs, fishing, hunting, four wheeling, and having fun. These were all things I enjoyed too. Our friendship turned into an intimate relationship as we grew closer within just a few months. He was laid back, had a decent job in a factory, and knew how to fix a lot of things in my car that always seemed to have problems.

CUP OF CLOUT

While writing this book, I spent an incredible amount of time reflecting on my childhood. In my younger years, I had many moments of feeling left out, not feeling good enough, and embarrassed of my situation.

We have many lessons taught to us in our younger years, some good and some bad. I built up a tolerance for stressful situations early on and had survived by gaining and using common sense. I was able to grow through and above the mess that my mom put me through.

You can overcome any challenge thrown at you, too. Your mindset is important for dealing with both your failures, as well as your successes. Surround yourself with people and situations you want to be more aligned with, otherwise known as good seeds.

When stressful, toxic, and unworthy seeds present themselves, don't plant them. Bad seeds ruin good seeds. However, do learn from them. Take those situations and turn them into lessons.

PART II

EARLY ADULTHOOD

CHAPTER 1

FINALLY ON MY OWN

I finally moved out of my grandparents' and shared an apartment in Columbus with my friend, Stephanie. She and I only ever hung out to party together. I met her about a year earlier at a party. She was always down for something new. Her wild hair was always teased up with way too much hairspray holding it up.

Our apartment was pretty basic and bare. I took my bedroom furniture from my grandparents and made do with very few kitchen supplies. We had outdoor folding chairs in the living room with the small television that had come from my bedroom as well. Bryan and his friends would come over from time to time, but mostly we hung out at other people's houses to party.

I was attending college and delivering pizzas to pay the bills. It was the best job. To keep enough money coming in for bills, I kept my job at the grocery store in Stromsburg too. It was a long drive, but the hours worked around the pizza delivery job and I wasn't sure where else I could work. Paying rent and all of the other bills that came along with living on my own was quite expensive, and I barely seemed to get by.

In the early days of delivering pizzas and not understanding addresses, I had to call my boyfriend Bryan for nearly every delivery and ask him how to get there. Over time, I learned my way around and even figured out shortcuts. I took multiple deliveries at a time and prided myself in being the fastest delivery driver. When the shifts were over, I cashed out and left with a wad of tip money and "mistake" pizzas that would otherwise be tossed. I would meet up with Bryan and friends to drink cheap beer and wine coolers, ride four wheelers, or just hang out.

Quickly, my apartment situation did not work out with Stephanie. Her parents told her she needed to live at home and save money. She seemed okay with it, and I was totally let down. Not only did it hurt our friendship, but she was supposed to pay me for half of the rent. I couldn't afford the apartment on my own. Thankfully, I had a good relationship with the apartment leasing manager and got them to let me out of the lease. I moved in with my boyfriend and his roommate, Clint. They lived in a two-story house in the country. My rent was so much cheaper than what I was paying for the apartment that I was able to quit working at the grocery store. My grandpa was upset with me when he found out that I was moving, but there wasn't anything he could do about it now.

After a few months, things became weird between me and my boyfriend. Bryan seemed to be getting more serious about our relationship and never let me have my own space. He would even randomly show up at my work just to say "hi." I was not ready to be so serious and was thinking about seeing other people. I wanted to be young and carefree. After all, I was still only eighteen. We talked about it, and he begged me to stay, though I was not sure I wanted that. Living in the same house made it awkward, so I started asking around

about places to rent. However, finding something as cheap as I was paying proved to be challenging.

It was a Husker football Saturday, and I was on for a split shift at Pizza Hut. I often had to work the lunch shift, then dinner, and the late-night rush. I delivered the lunch hour rush, then made my way through the car wash and home to get a few things done before round two. Evening football games coupled with Saturday nights were busy and my best nights for tips. It meant we could wear jeans and football gear rather than our uniforms. I knew my butt looked good in Lucky Brand Jeans. The jeans were complemented with Doc Marten shoes and the only husker sweatshirt I owned. I was ready to make some money. I barely kept up with sports because I always had other things on my mind, but this sweatshirt meant more tips. I packed up my wine coolers in the back seat for later and made my way back to work.

The rush hit about 5:00 p.m. At 5:17 p.m., I grabbed a delivery that was for a nearby home, yelled "time me," and out the door I went. I dropped the pizza off and was making my way back. While jamming out to *Ride the Wind* by Poison and scooting through the residential neighborhood, I approached an unmarked intersection. I looked to my left and saw a black SUV coming, but it was pretty far and assumed I was clear, so I kept going. The last thing I remember seeing was that same black SUV coming right at me, thinking I was going to get hit.

I woke up to a woman holding something on my head (after further examination, it was my work fleece). I began to realize I had been in an accident. How bad? Is my car okay? Why are so many people around me? Is the other driver okay?

What is going on? I had more questions than answers and started freaking out.

"I'm okay," I said. "I need to get back to work. Thank you for helping me."

"This is a pretty bad accident. You're not going back to work. You're going to the hospital." She instructed.

I heard sirens and they were getting louder. "Seriously?! They called the cops? I said I am fine." I said. She didn't respond to me this time.

There was no need to do this. *Man, my grandpa is going to kill me*, I thought to myself. Pretty soon, a man was crawling through my passenger side toward me.

"Can you move your arms and legs?" he asked.

"Yes, I am fine," I nervously respond. It was about now when I was starting to get nervous. Was I okay? No one would tell me.

"I feel something very warm on my face under my fleece," I explain to the lady who is holding it.

"It is blood. There is quite a bit, which is why I am applying pressure. By the way, I am a nurse," she said. I was relieved but still curious why there are so many people and what exactly happened.

The man started asking me if I knew where I was and what I was doing, and I suddenly recalled that I had just delivered a pizza.

"The money bag. Where is it?" I said. "I was delivering pizzas."

"We found it." He assured me. "Can you tell me your name?"

I panic. If I gave my name, they would've known my grandpa and told him before I could. "Carole Standley," I replied. This was my birth father's last name. At least my mom thought it was. I had gone by Carole Shepard, which

was my grandfather's last name, but he was the sheriff in the neighboring county, and I figured they would put two and two together and call him. Something like this would disappoint him, and I wanted to try to hide it. I figured this couldn't be that bad.

"There are going to be loud sounds starting soon. We need to cut your driver side door open. This will help us get you out of here," the man said.

I could not see much. One eye was covered with the jacket and I realize I was missing my glasses. Great. I couldn't see shit without my glasses. I reach out in front of me. What was this white thing where my steering wheel is? The airbag. *How cool,* I think. I always wondered what these were made of. But that meant the impact must have been substantial, right? I started looking around. From what I could see, I was close to, practically inside of, a bushy pine tree.

That's odd. I was on a road; how did I get here?

"I smell something burning," I tell the lady who relays the message to the man.

"A fire is starting; we need to get her out of there." I hear someone say.

Slowly, things are making sense. This wasn't a fender bender. They got me out of the car and loaded me onto an ambulance cart. So many people were standing around, staring at me. I asked for them to please cover me, since it was so embarrassing.

In the ambulance, they start undressing me. My shoes came off and they started cutting my jeans. I lost it.

"That's not necessary. My legs are fine. These jeans are expensive." No choice. Next was my shirt. It was cut off too. My best work outfit—gone.

We arrived at the hospital ER and I was wheeled in. Nurses and staff were running all over, prepping things. There were several people in the Bronco that hit me, and we all were in the hospital together to get checked out. I was freezing cold. I asked for a blanket and something warm and relaxing was placed on me moments later. It felt so amazing. I was wheeled through various scans and finally taken to a room. A few minutes later, my gramma came in. How in the hell did she find out?! Her eyes are swollen and full of tears. She's been crying and came to hold my hand. I begin to cry too.

"I am so sorry. I will make sure to pay for a new car." I cried to her.

"It isn't the car we are concerned about, Carole Sue," she replied as she held my hand. She looked at the nurse and said, "Get her cleaned up before her grandfather comes in."

Shit—He's here too? I bet he's angry with me.

They started messing with my face again and decided I'd need some stitches. My grandpa walked in and I started crying again.

"I am so sorry I did this. I didn't mean to wreck the car. I will fix it all. I didn't mean to cause you trouble tonight." I said.

"None of it matters. You scared us, sister," he said. "How do you feel?"

After I calmed down and looked up, I saw he'd been crying too. "I've had better days," I said smiling.

"I will review the report and we will talk about next steps," he said. "You get some rest and your grandmother, and I will be back tomorrow."

I laid there getting stitches. The doctor had the Husker game on in the background.

"You picked the worst time to get in an accident," the doctor joked with me.

"You're telling me! I am missing out on some serious tips right now!" I shot back.

That has me start thinking about my night and I recall the alcohol in the backseat of my car. If the cops find that, I'm screwed. At some point during my stitches, Bryan walks in. He's been crying too. His face is flush, eyes swollen and filled with tears. Was it really that bad that everyone would be crying? He comes to me and grabs my hand.

Things are still awkward between us. I couldn't understand why he would come to see me when I've been spending my time trying to avoid and break up with him. But, right now, I am so thankful to have familiarity around me.

When the doctor stepped out, I said. "There are wine coolers in my back seat behind the passenger side. Can you figure out how to get those out of my car before the cops find them?"

"I'll take care of it." He said.

"I think I'm outta here after these stitches." I said with certainty.

"No. I'm pretty sure you're here for a couple days. Not trying to hurt your feelings, but you look like shit and you are probably going to be pretty sore tomorrow." He replied. "I called in sick to work tonight to stay with you." I was shocked. I'd treated him like shit the last few weeks and he was going to stay with me.

I was taken up to my room in the intensive care unit and hooked up to everything imaginable—monitors, tubes and IV's.

"You've broken both of your shoulders, have pulmonary contusions, and severe facial lacerations, and are quite lucky

to be in this good of shape." My overnight nurse explains. "What is your pain scale on a one to ten?" She asked.

I had been so busy in the moment that I hadn't really given much thought to the pain. It was noticeable and I had a pounding headache.

"I have a massive headache and am freezing cold again." I replied.

"I am going to give you some pain medication and I will be popping in and out all night to check on you. Why don't you try to get some rest?" She said.

Whatever she put in my IV helped me finally relax and close my eyes. It didn't last long. I woke each time she came back to my room. I was so restless and realized that it was impossible for me to roll to either side. She could tell how restless I was.

"We are going to try something a little stronger." She said.

"What time is it?" I asked. Without my glasses, I couldn't see anything very well.

"It's about two a.m." She replied. "This medication should help you get some rest."

I woke up to sunshine coming in through the window and a tray of liquids over my bed. Broth and Jell-O was my breakfast. Wowzers, did I feel achy. Like all over, completely miserable, tubes going in and out of me. I have a new nurse now, and she's equally as friendly. Whatever pain medications they kept giving me, I kept taking. Usually, I can shake off pain and keep going. This was unlike anything I've experienced.

Bryan was walking in around the time I begin to eat. He looked rough. The nurse asked if he was hungry and brough breakfast in for him. Lucky bastard gets food, I thought. As envious as I was, my breakfast seemed fitting. I didn't have

much of an appetite and I was still exhausted. Bryan stayed for a while and we engaged in small talk.

"I had someone get the wine coolers out of your car without getting caught. So, we got that taken care of." He said. "Your car is totaled. It looks bad. You are lucky to be here." He teared up again.

"Thanks for taking care of that." I said.

"I'm going to head out and get my mom. She said she wanted to come see you when you were up." He said.

This worked out great because I loved nothing more than a shower.

"Can I take a shower?" I asked the nurse.

"I'm happy to take you and give you a bath." She explained. "I think you are going to need some help getting around and we need to unhook several things."

"No, I just want to go take a shower. I am sure I can handle this. If you can unhook everything and let me go. I've had my downtime. A shower will revitalize me." I insisted.

She complied and went to work unhooking almost everything. It appeared I'd have to drag an IV with me. It's a fair compromise, I suppose.

"With your broken shoulders, you will need to have some help sitting up and walking." She said. I felt embarrassed. I hated being vulnerable and weak. I hadn't broken any bones before, so I was unaware of what I was in for.

She turned on the shower and I stepped in. The freezing cold water shocked me and I hit the floor in no time, resulting in more pain. She quickly helped me up.

"I told you to wait for me to help you." She scowled.

"I just wanted to take a shower on my own." I shot back. "You should have told me the water would need to warm up first."

After the shower, I slowly walked over to the mirror. I hadn't seen myself since this ordeal. Without glasses still, I had to get in close. As I leaned in, I began to cry. My face was awful. Bloody scabs and bruising covered my pale skin. I looked awful. I threw my towel over the mirror and vowed to not look at that again.

"Where are my glasses?" I asked the nurse.

"I'll see if they came in with your stuff." She replied. She left and came back with them. "They are pretty beat up, but here they are."

I slipped them on. It was as if a bunch of rocks have been thrown at them. They were intact but useless. I took them off. "Thanks for grabbing them, but I still can't see."

Bryan and his mom showed up later and she brought me, of all things, underwear. Not just any underwear—granny pants underwear. Outside of the style—How did she know I needed these?!

The rest of the day was spent listening to music on CMT—since you don't need glasses to listen. That evening a few coworkers and my manager showed up with some pizza and breadsticks for me. They too, started to cry when they saw me. After my run in with the mirror, I can't blame them. I'd let them know that I would be back in no time and not to worry.

Bryan was still with me and called in sick again to work. He was being affectionate and got me anything I needed. I didn't understand. On one hand, I wanted him to leave. On the other, I was thankful that someone was staying with me. It was so confusing to me. Was I supposed to be with him? Or was I supposed to be single for a while. I decided to just go with it. After all, I had enough to worry about now.

The next day my mom called. "Hi honey. How are you? Mom and dad called and told me you were in an accident."

"Wow," I thought. What a concept for her to care about my well-being. "I'm fine. A bit sore but fine," I said.

I spent another couple days in the hospital. Each day was about the same: seeing friends that stopped by, listening to country music, and resting.

On departure from the hospital, Bryan was able to drive me to my grandparents' house to spend a few extra days at their request. Since he hadn't really left my side during all of this, I was ready to have some time apart. Everyone helped me up to my old room. My gramma had refurbished it since I'd moved out. I popped a few pain pills and settled in.

My grandmother was the best caretaker. She instantly worked to make me comfortable and brought me anything I wanted to eat. Late that night, I had become increasingly uncomfortable throughout my body. She came into my room and sat on the side of my bed.

"How are you feeling?" She asked.

"Awful." I said. "I'm achy all over."

She pointed to my lower back. "Is your back sore?" She said.

"Yes," I replied.

"Can I have a look at it?" She asked. I agreed.

"Well well, what do we have here?" She said as she pointed to my tattoo.

Shit. "Umm, well Stephanie and I wanted to get matching tattoos."

"Cute," She said. "I have one too."

"What? No way! Let me see it." I exclaimed. She stood and pulled her pajama pants down a bit and pointed to the top of her pelvic bone.

"I don't see anything." I said. "What is it?"

"A mouse." She replied. "Get closer."

"I still don't see it." I assured her.

"Damn. Pussy must've got it." She laughed. Speechless, I began laughing. She joined me. It was a fun moment for us, which we hadn't had in a long time.

"My lips are sealed." She assured me as she left my room.

The next day was a lot like the previous with resting, eating, and country music in the background. I woke in the middle of the night in excruciating pain. As I cried out, my grandparents ran in.

"Call for the ambulance, Bud." My gramma said to my grandpa. He disappeared to do so.

"Where is the pain?" She asked.

"Everywhere. My muscles are spasming all over." I cried as I gripped the bed and anything I could get my hands on.

The ambulance soon showed up. I recognized Jim Lewis who was the fire chief and owned a full-service gas station in town. Jim's gas prices were the highest in town, yet my grandpa always fueled there. When I asked him why, his response was, "That man saved my life. When I had a heart attack and was laying in my driveway, he was the one who found me and got me to the hospital. I can never repay him. So, I will always get my fuel from him." It was these stories that my grandpa told that I still to this day think about and work to apply the lessons.

Jim lifted me to a stretcher and to the ambulance we went. As we rolled through the yard to the ambulance it was raining. I laid there helpless as the rain ran down my face.

"Can we go back to the hospital in Columbus?" I asked. I didn't trust the small hospital we were at, and since Columbus was already familiar with my situation, I felt more comfortable going back there.

"We have to take you to our local hospital." They responded.

I became upset, which escalated the pain even more. When we arrived at the hospital, I insisted on going to Columbus and refused to be treated there.

"If you want to be treated in Columbus, your family will need to drive you." The nurse explained.

"Fine. I will find someone to take me." I said.

My gramma drove me to Columbus. By this time, my pain was reducing a little because I had taken a new round of pain medications.

After being examined the nurse said. "You really shouldn't miss any doses of your medications. They are prescribed for a reason."

"I must have slept through a dose which caused the additional pain." I admitted.

"Gramma, when I am able to leave again, I am ready to go to my own home and rest." She agreed, though she looked a little disappointed.

The next day Bryan drove me back to our place. I was slow getting around and couldn't do much. I couldn't lift anything, had a difficult time washing my hair, and shaving was out of the question. I felt helpless.

My friend Kassidy would come over and play Monopoly with me to pass the days. I finally got new glasses and started the process with the attorney for getting the legal matters revolving around the accident figured out. My grandpa got me hooked up to borrow an old Ford Tempo car from an old relative of his. He also loaned me $3,000 to help me get by until I could start working again. It felt like another setback to need his help still.

I knew I had a long road to recovery ahead. I was told many times over how lucky I was to survive and even walk away with few injuries. It was a month before I could go

back to work and I was stuck in the kitchen making pizzas for another month. Even then, I was timid when it came to delivering pizzas. Anything near the car accident was a delivery I wasn't taking. I didn't want to remember that day.

CHAPTER 2

AN ARRANGED MARRIAGE

———

At the end of 2002 and a short two months after my car accident, Bryan and I ended up moving to Duncan and renting a small home. It was so small that a vacuum could be plugged in in the living room and make its way through each room. We didn't even put up a Christmas tree that year. I still needed help with small things and felt exhausted most of the time. A couple months later, on Valentine's Day, he came home from his overnight shift at work and brought me French toast sticks from Burger King and proposed to me. I said, "Yes." A white gold ring with center marquise diamond and a few small diamonds on each side made its way onto my ring finger. It seemed like that was what I was supposed to do and say, considering everything. I did figure, though, that I still had time to change my mind. After all, we weren't in a hurry to get married.

Jump to early December of 2003. I sat in my grandfather's hospital room after being told he was in hospice. I didn't understand what that meant. I knew he was on oxygen and had heart problems most of my life, but I still didn't understand. It was almost my twentieth birthday, and a bit teary eyed, he explained that he was unable to get me anything for my birthday. A gift was the last thing I expected when I just wanted him to be able to go home. He was barely into retirement and there were so many things he still needed to do with his life.

"With all of the talk going on, I am wondering if you were going to be able to be at my wedding in the summer?" I asked.

Bryan and I hadn't set a date yet since we had only been engaged for eight months, but we knew it would be sometime in the summer. I'm not a big planner anyway and typically do things as they come up.

"Give me a couple days to think on that, sister," he said. We continued with other small talk. His previous chief deputy, Jim, who was now the acting sheriff, stopped by to say hello to him. They had been good friends for quite some time.

"How have things been going for you since the accident, Carole?" he asked.

"Good. I'm between jobs, though. I want to spend more time here with grandpa, which didn't work well with my other job," I said.

"I'm hiring for a dispatcher," he said. "You should apply." My grandpa was less than thrilled. I knew he always wanted better for me. But, needing a job and feeling like this could get me closer to him in the ways I knew as a child, I quickly applied and got the job.

On my birthday, December 6th, I stopped by the hospital to see my grandpa and tell him the news about me going

to work at the sheriff's office that he had worked at for so many years.

I was barely able to sit down when he exclaimed, "I spoke to Verna at the courthouse and she can marry you this Sunday!"

Shocked, I replied, "Sunday, like this Sunday? What? Are you kidding? That's such short notice. How will I get everything in time and let everyone know?" I had more questions as I looked at his serious facial expression.

"Do you want me at your wedding or not?" he replied.

"Of course I do, Grandpa," I said.

"Then, this Sunday it is," he replied. "I believe that is the fourteenth, as he looked over at the calendar.

When I left, I called Bryan to share the news with him. He seemed okay with all of it. Not surprising. I was the only one hesitating. Miss Impatient really wanted to be patient about this and we didn't have time for that.

On December 8 we moved my grandpa into the nursing home. He always told me the story about his own father in the nursing home and having to take the cane away from him because he struck the nurses with it. From what I gathered in previous conversations, his father was pretty strict with him too.

As we were situating him in his bed, I caressed his forehead. He was sweaty and felt cold to the touch. I leaned in and whispered, "How about I get your pickup, back it up to the window, and bust you outta here?" He smiled but continued to look past me. That day he didn't make eye contact with me and seemed so distant.

I felt weird about leaving but decided to head to my grandma's house to visit her and play cards. A few hours later, we were in the middle of a game of rummy when she

got the call that my grandpa passed away. I didn't believe it and told her I would go see for myself. She stayed at home.

When I got to the nursing home, I made my way down the hall with familiar faces looking at me. When I got to his room, he looked at peace. He was no longer sweating or struggling and appeared to be relaxed. I sat on his bed talking to him for a bit before going back to my grandmother. She had been through the loss of family before and seemed like it was something more to deal with. Cigarette in hand, she was working out the details of a funeral for him.

Two days later on December 10, I started my new job at the place my grandpa had spent the last several years working at. It seemed so odd yet comforting. One of the older ladies, Jan, whom I had known for years was working and asked how my grandpa was doing. "He passed away two days ago," I replied. She shared her sympathy with me and said she enjoyed working for him.

The next day, my gramma reminded me that Verna from the courthouse was scheduled to come to her home on Sunday to marry Bryan and me. I had forgotten about that. I felt like it was something I had to do for grandpa since he arranged it. So, we proceeded.

We had my grandfather's funeral two days later on the twelfth, then my wedding two days after that on the fourteenth. Due to short notice, we ate lemon funeral cake the day of our wedding and didn't bother to wear anything special. We had a very basic and sad wedding in the living room of my grandparent's house, which felt like it was all for my grandpa.

My mom decided she couldn't afford to stay for our wedding and left after my grandfather's funeral. Another let down from her wasn't anything surprising to me.

Bryan and I were broke newlyweds. I had been between jobs and spending quite a bit of money driving back and forth from Duncan to Osceola to see my grandparents during this period.

After the wedding, I told Bryan we should have a baby. I thought a baby might fix the craziness of our lives and give me something else to love and take care of.

On January 7, I found out I was pregnant. I called my mom first. She was ecstatic. I didn't know why I called her. Perhaps it was because I was a bit scared to call my grandmother. When I finally did tell her, she was upset with me and said how foolish I was being. I figured as much. She made me feel like I let her down at times, and this was one them.

Two months later, I got the call that my stepdad, Billy, had a stroke and was in the hospital unresponsive. Days went by with no improvement. At the age of forty-nine, he was taken off life support and passed away. This began the serious decline of my mother, which trickled over to my sister who was only thirteen at the time. My mom's drug and alcohol use increased and her desire to be a good mom decreased. Although my mom and stepdad fought all the time, my mom loved him dearly.

I sat through my stepdad's funeral thinking about how this was a much better funeral than the one I was just at a few months ago. How could I be so cold? Who was I to be comparing funerals anyway? My grandfather's funeral was a ton of scripture, which was ironic for someone who used to tell me, "If there is a God, then why do good people struggle, and bad people prosper?" My stepdad's funeral was personal and interactive. Men wore hard hats representing the railroad.

Music was played to symbolize his life. I remember the song "Free Bird" by Lynyrd Skynyrd playing and remembering how relevant that was to his life. He put up with a lot over the years with my mom, and now he was free.

In October of 2004, Bryan and I welcomed Hayden to the world, and I became a mother. He had sandy blonde hair and blue eyes. After everything that we had been through, I welcomed this new life to love and nurture. I felt in control of this and felt I could make a better life for another person than I endured over the last twenty years. By this time, my gramma had completely fallen in love with the idea of a great grandbaby to love.

I was so involved as a new mother that I hadn't given much attention to my sister or mom. My mom started calling me about problems with Hayley. Apparently, she was missing school quite often and getting mixed up in drugs just like my mom was. I would discuss this with my gramma when Hayden and I would visit her. I just couldn't understand how my mom would let Hayley get into so much trouble. Even though my mom was addicted to drugs, she often admitted that she wished she could change. I never understood why she wouldn't push her own children to be better. Being a new mother, I often thought about how I could be a better mother.

Hayley was eventually taken away from our mother and became a ward of the state. She was truant more often than allowed, and since my mother wasn't doing anything about it, Hayley wound up in the foster care system.

Bryan and my marriage suffered. I blame myself, mostly. I wasn't ready when it happened and having a child certainly

didn't help us. I had always trusted my gut, and while Bryan was always there for me, my gut kept telling me that something needed to change.

At work, I became close to Chad. He held me accountable to my job, yet took time to get to know me. He was tall, dark, and handsome. He was also not afraid of any task. We shared similar interests, and I felt that because my grandpa had hired him to work for him, that he must be trustworthy. We became closer by the day, which became obvious to everyone around us.

Even my own grandmother told me that I spoke more about Chad than I did my own husband. For a woman who was so upset with me for getting pregnant, she sure loved Hayden. She insisted that he was at her home as often as possible. She let him crawl around and do anything he wanted.

As Chad and I grew closer, Bryan and I grew further apart. Getting married and having a baby drastically changed my relationship with Bryan, and we both knew it.

In early 2006, Chad and I had developed feelings for each other, which we were both lacking in our other relationships. We also worked well together. By February, I told Bryan I was moving out. I had left my job in Osceola and accepted a job in Columbus. I was renting a lake house and ready to move on from that life.

Chad was also starting the process of a divorce. He had a four-and-a-half-year-old son named Logan that he got to see a couple nights a week and every other weekend. Logan had darker hair and took after Chad in height, being one of the taller boys in his class. Logan and Hayden played well together.

A couple weeks later, my grandmother ended up in the hospital with what we thought was bronchitis. It was there

she confided in me that she now knew what she put her mother through in her younger years. We became so close by sharing our stories over the next few days. She told me that she left her husband whom she had my mom with to be with my grandpa, and together they had my uncle Buddy. I was shocked.

I was at a new job in Columbus as a CSR for a heating and cooling company and trying to spend as much time with her in the hospital. One afternoon, I arrived and found she had been transferred. The hospital staff explained that her symptoms had worsened, and she needed to go to Omaha for further care. Not only was I at a new job, with a young child, and in a new home starting the divorce process, but my grandmother's health was also declining.

I spent the next several days in the hospital with her, and my family scowled at me and blamed me for her illness. My uncle, great aunt, and mom were all aware that I was leaving my husband and blamed me for my grandmother being so ill. She suffered from COPD and emphysema, and somehow my failing marriage was to blame for her health.

Since my sister was a ward of the state of Kansas at the time, they wouldn't let her ride with my mother to see our gramma. Time was of the essence, and Chad told me that he knew of a pilot in Columbus who could fly us down to Topeka and back much quicker than driving. He even offered to loan me the money to do this. Having not slept in days and wanting my sister to be there, I took him up on the offer. We got Hayley to the hospital with enough time to spare. My mom had left before we got back to the hospital. It was something about needing to get more money to stay longer.

Because there was no other responsible party there, I became gramma's power of attorney and had to make the

decision to take her off life support, which resulted in several hours of her struggling for her last breaths. She passed away on March 5, 2006. My mom wasn't even there to say goodbye to her own mother.

My employer was kind enough to let me miss so much work, but also didn't compensate me for my time off. I certainly didn't expect to be either. I was never one to expect anything from anyone. I had never had anyone else I could count on. The more things I had to figure out the hard way, the more debt I incurred. My grandmother had a life insurance policy. Unfortunately, she didn't have the policy long enough, so my benefit was the return of premiums. I got about seven hundred dollars, which didn't even cover what I owed Chad to have a private plane fly my sister to Omaha in just enough time to say goodbye to my grandma.

My divorce was the final straw to the pile that caused it to knock over. Bryan wasn't paying his share of the debts and was hit and miss on paying child support. My only way out was bankruptcy. My divorce attorney explained that there were debts in my name and even though they weren't my responsibility, it didn't matter. It was an embarrassing time, for sure. This was in the middle of a series of years where I felt like I was in a hole. Every time I thought someone was giving me a ladder to get out, it ended up being a shovel. The deeper I went, the more problems, more debts, and struggles I faced. My twenties were starting out very trying for sure.

It's always been in my nature to do things the hard way, and I've been bullheaded enough to accomplish anything I set myself out to do. I might wait until the last possible minute, but I will almost always come sliding in with the project finished. On the rare occasion that I don't complete

something, it wasn't meant for me anyway. I would just dust myself off and move on.

In hindsight, I experienced four major life events in nine days. I entered my twenties, lost my father figure, started a new job, and got married. Within four weeks of that, I found out I was pregnant with my first child. A year and a half later, I started the process of a divorce while also grieving over the loss of my gramma. Life spun around and around in my early twenties. I held fast as I knew there something good had to come from all of this.

CHAPTER 3

GETTING MARRIED FOR THE RIGHT REASONS

——

It was another dreary day in April 2006 at my somewhat new job at the heating and cooling company. One of my supervisors approached me and asked that I reconsider clothing choices and dress more professionally. Apparently, my jeans and sweater weren't professional enough. I nodded and agreed. As I sat there begging for the day to end, I wondered where I would come up with the money to go shopping for clothes. After all, my bank account had twenty-five cents in it and payday wasn't for a few more days. Even then, my bills were already eating up my paycheck and I still needed to get groceries. Even worse, the week I took off just the month before, when my gramma was in the hospital and after she passed, made my paycheck almost nonexistent.

I spent the rest of my day doing the math in my head over and over, thinking of ways to get ahead. I wasn't where I wanted to be, and I couldn't stand the thought of always being behind.

That night, I made Hayden a bologna sandwich, noting that there wasn't enough bologna for both of us and not much else to choose from. I let him have the bologna and made a grilled cheese sandwich for myself. Hayden was just learning to walk and was anxious to finish his dinner. He shared a bite with me and ran off. I've always loved his blue eyes and thoughtfulness.

Later that evening, Hayden was playing in the bath and I decided to go through the tubs of things from my gramma's house. I came across a toy. Not just any toy, but a purple caterpillar toy with the ABCs as the legs. This was a toy that my gramma bought for him and kept at her house. At this point, it had only been about a month since she passed away. I pushed a button and a song started to play. Hayden perked up and stared all around. To this day, I think he was looking for her. I felt terrible. He knew something wasn't right. I cried myself to sleep that night.

The thought this life wasn't what I dreamed of. I found myself wanting something more, but every time I thought I was climbing out from the bottom, I just got more behind. I lost so many family members by this point and felt so empty. Chad and Hayden were the only things holding me together.

In July 2006, Chad and I moved down to Hebron, Nebraska. In the last couple of months, Hayden had developed a food allergy that was serious enough that prevented him from going to daycare. I had no choice but to take my job back at the sheriff's office, which was forty-five minutes away, while Hayden stayed with his father overnight. I didn't sleep much

during the days with him at home but was still able to make enough money to pay for things like my lengthy divorce.

My uncle Buddy—who Hayden got his blonde hair, blue eyes, and petite figure from—used to come visit me in the middle of the night while working at the sheriff's office. He and Bryan got along great. That was how Hayden used to see Uncle Buddy since I didn't get along great with him and we now lived farther apart. Overall, we tolerated each other.

When my grandparents were alive, they used to tell me about how Uncle Buddy had a severe alcohol problem in his younger years. He had gotten sober for about ten years but his girlfriend, Brenda, was sure to get him drinking again. My grandpa warned her about the Buddy she didn't want to know. That didn't stop her, though. Buddy took to drinking again, which caused them to break up. In a rage, she drove to his house one day in such a hurry she blew right through the stop sign and was hit by a semi. She lost her life and Buddy spiraled out of control even further. His drinking took a turn no one expected.

It would be three or four in the morning when Buddy would stop by to see me. He would make me feel guilty for moving away and say that since his father and mother left him, it had not been the same. Then I left too and now he only gets to see me at work. His drinking and depression always had him bringing everyone else around him down. He confided in me that he would be the next one to pass away and that his friend Phil would be the one to find him because no one else cared. I didn't disagree. I had my own problems to deal with and he seemed to add to them.

The long drive and night shifts were starting to weigh on me. So, I started an in-home daycare in early August to stay

home with my son, sleep at night, and spend less money on gas. To me, the plan was brilliant.

My uncle's birthday was August 17. It was late, around 11 p.m., when my phone rang. My sister was bawling on the other end. She said that Buddy was found, and he had passed away. My heart sank. It was only weeks before when he spoke about this very scenario. After further investigation, Buddy passed away on his birthday from an overdose of drugs not prescribed to him. Phil was the one who found him.

No one could afford a funeral. We ended up having a celebration of life meal at the Osceola Tavern. As I walked around speaking with people, it dawned on me that we didn't have as much as a meal to celebrate my grandmother's life. My mom took care of the details for my uncle but hadn't done anything for my gramma.

After about a year, my mom's life spiraled out of control. My sister was still a ward of the state. My mom was so absent it was unreal. She was always gone and drugs became even more important to her. I couldn't keep track of which town my sister was in since the foster care system moved her around. I couldn't handle it and felt like, in the same manner my grandparents did, I needed to step up. I felt compelled to take care of her as I did when she was so young. Chad, Hayden, and I had just moved into a larger home and things were starting to look brighter for us. We brought Hayley out of foster care and into our home shortly before her sixteenth birthday.

At the age of twenty-three, I had to learn quickly about a guardianship and conservatorship through the county and

state. Hayley was a surviving minor of a deceased railroad employee and keeping track of her money and well-being was not only the right thing to do, but also court appointed.

When things were being finalized, our mother asked me if she could still have the financial benefit check each month since it had been in her name in months past. It had not been long ago that I was the child overhearing the same conversation about money being sent for my care, and now my mother wanted the money for my sister's care. After several conversations about her daughter's money and my divorce, I opted to remove her from my life. Hayley and I talked about this and we both knew I was trying to give us a better future.

Chad had a friend who was also in law enforcement with the state patrol. His wife Missy and I became friends. She was a dispatcher for the sheriff's department in Fairbury. I was envious. I missed that type of work. When there was an opening, she encouraged me to apply for it. It was an overnight shift. I had grown to liking having an in-home daycare, but I also missed the benefits and socialization. Since Hayden was getting older and would soon be going to kindergarten, I applied. That November, I got the job. It felt like picking up where I left off. This agency was busier than my previous and I liked it.

Within a few months there was an opening in the police department in Fairbury. I encouraged Chad to apply for it because it was better pay, benefits, and hours. He did and got the job in July. This meant we needed to move into the city limits of Fairbury.

In August 2008, we relocated to Fairbury, Nebraska. This was such a fresh start for us. We both were finally making more money and our work hours lined up perfectly so we had the same days off.

The day we moved to Fairbury, Chad and I found out we were pregnant. It came as quite a surprise to all of us. I became nervous because we had just started getting things figured out and now had another person to be responsible for.

That December, Chad and I took a vacation to Florida. During the trip, we took a helicopter tour over Miami at sunset. Chad proposed to me. I said yes! The white gold ring with a round shaped diamond was just what I had hinted at wanting. It was perfect.

I wasn't sure if it was the motion, lunch we had, or being four months pregnant, but I began to feel sick. I began to vomit with no container or bag in sight. It was awful and so embarrassing. As we landed on the floating dock, I desperately needed to get out of the helicopter to find a bathroom and new clothing.

"Do you still want to marry me?" I asked as we walked out of the clothing store. I had already changed into clean clothes and my dirty laundry was in my shopping bag.

"Of course," he said. "I was about to ask you the same thing," he chuckled.

As I lay in bed that night, I recalled that it was the six year anniversary of my grandpa's funeral.

What a day to get engaged, I thought.

On January 23, 2009, Chad and I got married outdoors in seventeen-degree weather at Crystal Springs right outside Fairbury. It was a private wedding with just us and our witnesses present. That evening, we went out to dinner at Rowdy's Steakhouse to celebrate. A week later, we celebrated with a family dinner at Chances R in York, Nebraska.

Mason joined our family in May. He was perfect. He had similar blue eyes and hair to Hayden. I was not able to go back to the sheriff's department for work, so I began the job hunt. I found a door-to-door insurance sales job that seemed to be pretty flexible with hours. The opportunity came back up to reopen a daycare and knowing that would give me more time with my two boys, I began a daycare again.

The house we were in a contract to buy fell through because the appraisal came back too low. Secretly, I was happy about that. I didn't really like our house anyway. We found another home across town to rent. Hayley was turning eighteen and did not want to move with us. The new house wasn't big enough to run a daycare from, so the job hunt started again.

Hayley, being very much strong-willed like me, abruptly moved out as quickly as she could. I couldn't blame her. Some people can't be tamed. She stayed with us until she was eighteen then took off. We took about a year off from really talking much. She was young and hardheaded, much like I was.

I found an insurance-related job that was about thirty minutes away with part-time hours. I didn't mind the job, but I really started to feel like everything was temporary.

Within a year, Chad, Hayden, Mason, and I finally had the opportunity to buy a home in Fairbury. It felt nice to have more space and a place to really call our own. I picked back up doing in-home daycare and we decided to add to our family again.

In June, 2011, we welcomed Ethan to our family. His dark hair and dark eyes were closer in resemblance to Chad and Logan. Our family was finally complete.

I started to feel a bit more in control of things. Hayley and I started to get along again, and I was grateful to finally be a sister and not a parent to her. That September, she and her boyfriend announced that I was going to be an aunt.

I started a new job at the vet supply office in town faxing requests and following up on open orders in the fall. It was, by far, one of the most boring ways to spend a day. But I craved social interaction and being out of the house.

Mason, at the time, had a problem with biting other children at the daycare and was on his last life there. This had been a problem for a while now. I had a toddler and a newborn in daycare, and it was quite expensive. It really didn't make sense for them to be in daycare to begin with due to the cost of daycare and my pay at my job. I knew I needed to do something to try to fix this, too.

The cleaning crew wasn't doing a great job in any area. One day, I walked into our office area to find Honey Barbecue Fritos all over the floor near the trash can. I had eaten some the day before and threw the remaining bag in the trash can. Apparently, they got spilled over while dumping trash and not cleaned up. That was it for me. I walked into the human resources office and asked how much the cleaning department got paid to not do a job. After a brief conversation and learning that cleaning the business meant not just cleaning the offices, but also cleaning the owner's home, I asked to be considered for the position. Having helped my gramma years before, I wasn't bothered by this opportunity. Plus, I wanted the chance to prove to the owner, Doug, that I could do more than fax things.

I got the position within the same week that my sister made me an aunt to Alekay. He was born with the same red hair that Hayley's father Billy had.

This new job allowed me to take Ethan and Mason out of daycare, finish my associate's degree, make better money, and get to spend time around Doug and show him that I am capable of so much more.

After my degree, I still wasn't ready to prove anything to Doug, so I took the job at a newspaper and printing company. The owner, Fred, had several businesses in town. He was always bouncing from one to the other. It was fascinating to learn how each business that he had supplemented the others.

My position at the newspaper was as their circulation manager. I was tasked with increasing circulation. I ran promotions and followed up on expired subscribers to increase our numbers.

Soon though, I came across another newspaper running a Newspapers In Education (NIE) program. I learned more about it and found a solution to help offset the cost. We began that program as a way to increase numbers. What I ended up with was a passion for getting a tangible print product in the hands of young people. I had often recalled the times that reading helped me escape my reality as a child. I had hoped to give children the same outlet with their local newspaper.

I kept my cleaning jobs just in case this other job wasn't going to work out, and in case Doug wanted to hire me back into a management position, which is what I had hoped for since my earlier days of faxing things for his business.

Around the same time, I brought my mom back into my life. My sister had been talking to her off and on and brought her back into her life a little at a time. I knew as a new mother that she wanted her own mom to be involved. I respected that because they always had a close relationship with each other.

Mom was in a homeless shelter in Kansas and she still had the same "we can get through anything" attitude. Life had

been hard on her. Everyone else had passed away or walked away. She had no one.

Bless Chad for letting her move in with us. We had been through so much already. My mom looked like hell. She had a serious addiction to pain pills and looked rough.

In theory, it made sense. Not only did we have Hayden, who she only got to know early in his life, and Mason, who she had yet to meet, but we also had Ethan, who was a baby and she hadn't met. Plus, we were only a thirty-minute drive from Hayley and Alekay.

Unfortunately, that move was a nightmare from the beginning. Having a husband in law enforcement and a mother with a drug addiction wasn't a great combination. When we realized this wasn't working, my sister stepped in and took our mom in.

Throughout my whole life, my sister has been such a caretaker. When we were really young, she always wanted to make me happy. She'd do anything to hang out with me when we were little. After I had to move to my grandparents, she had to step in and start taking care of things around the house. Having our mom live with her and her boyfriend and my new nephew was a great fit.

CUP OF CLOUT

*"In every adversity lies the seed of an
equal or greater opportunity."*

NAPOLEON HILL

My twenties were filled with so many ups and downs. I lost
several family members and welcomed children of my own.
I truly enjoyed taking care of my boys and others around
me, but still felt something was missing. Everything felt so
temporary. I never felt like I was doing anything for myself.
My family seeds were my only focus during my twenties. I
worked jobs for a paycheck and always came up short. My
professional seeds needed much attention.

Opportunities exist all around you, but you do need to
open your eyes, ears, and imagination to find and create
them as well. Sometimes good seeds get planted in your gar-
den when you don't even know it because you were tending
to others. Focus on each seed but from time to time, step
back and review the whole garden. Looking at the big picture
reminds you why your garden is laid out the way it is.

PART III

ENTREPRENEURSHIP

CHAPTER 1

TURNING 30

———

As I neared my thirties, I felt like a failure. Turning thirty was weighing on me. Considering most of my family barely made it to sixty, I figured I was having a midlife crisis.

How was I going to leave a legacy for my children living paycheck-to-paycheck? It made me nervous. Knowing that I could always figure out obstacles, I began reading motivational and inspirational books again—something I hadn't done in years. I also allowed myself to dream. I had spent the last several years having babies and working various jobs just to keep afloat and I hadn't worked on myself.

After many years of various jobs and moving around, we had a home with a mortgage and my husband was promoted at his job to the police chief. Things were working out well and we began to get ahead.

I held onto, and still do hold onto, the fact that I was not where I wanted to be, but I also knew I was not done yet. I'm still not. I might have gotten a later start than others, but I was going to finish this race called life stronger and leave my children better than they entered the earth so that they could level their kids up too.

It was a crisp fall Sunday afternoon, the leaves were changing colors, and the warm rustic smell was present in the air. Sundays were the days I cleaned Doug's house. I had come to admire him throughout the years. He was the first mentor I had who I thought fit the definition of "entrepreneur."

Doug and I were having a bourbon and making small talk. He had introduced me to bourbon. I loved the flavor and the experience behind each bottle. We always share our good bottles with each other. I prefer mine neat while he has a sphere-shaped cube in his.

"You know that waters down good bourbon?" I tease.

"You prefer your way and I prefer mine," he said in a matter-of-fact way.

My birthday was approaching in a couple of months, and it was a big one.

"Big 3-0," I said. "It's coming. I can't help but think that I haven't accomplished all the things I wanted to."

I don't know why that slipped out, but it had been on my mind a lot lately. I was getting nervous about hitting my thirties and not having accomplished the things that I really wanted to in life.

Doug took one more sip of bourbon and looked at me and said, "Girl, the thirties were the best years of my life. Forties weren't so bad either. Now, it's the fifties that you've got to be concerned about."

We both chuckled and continued our conversation. Later that evening, I was reflecting on the things that he said and realized that he was right. I did need to start to develop a plan. After all, I had done so many things, career wise, that I really could do anything at this point and there was still time.

A year and half went by with me working the full-time job at the newspaper and printing company during the day. At night, I was cleaning businesses for extra money. My cleaning jobs kept me in shape and gave me several hours of alone time. I listened to many Audible books about business, personal growth, and mindset to focus on a better future for my family.

However, few years later, my sister realized she needed something different in her life.

It was our mother's birthday, and I was taking her out to dinner at a restaurant called Lazlos in Lincoln. After three martinis, she confided in me that Hayley was getting on a train that night and heading to Colorado to live with someone new. My mom and Hayley's soon-to-be ex-boyfriend got along great. I was sure she would stay living there. Though I was shocked, I wasn't entirely surprised. Hayley and I are similar in that we crave new things. I dropped my mom off at their home and headed back to my normalcy.

I knew based on her sunken face, our conversation, and her forgetful and sad demeanor that she was entering back into the dark world of dangerous drugs. Her life was heading down another rocky road. It was like talking to a blank slate.

I wanted so badly to talk to her about how my job was going at the newspaper and how I was being trusted with so much important work. I wanted to tell her that I loved my cleaning job because I felt like I was closer to gramma. I missed her so much. I wanted to tell her that my boss and I had recently learned about a magazine business for sale in Omaha and I dreamed of owning it. I wanted a mom. I had always wanted her to be a mom. She never came through for me.

I paid our tab and we left. I dropped her off that night remembering that Hayley was "running away" that night to start a different life of her own. I found myself feeling proud of her for working on her rather than everyone else around her.

CHAPTER 2

LIVING ON THE EDGE

———

Just a couple months prior in May 2015, my boss, Fred, was approached about selling a business he owned. He owned a variety of businesses and each complemented another in some way. I was always fascinated with the idea of having multiple revenue streams that all worked together to build each other up.

We drove to Omaha to learn more about the opportunity. After discussing the opportunity of a business being sold with the business broker, she presented a copy of the April 2015 issue of Edge Magazine to Fred as a reinvestment opportunity. It was stunning. I fell in love. He had no interest.

I took the magazine and read it cover to cover. The writing, photos, paper quality, and the way it left me feeling were so wonderful. It was yet another way I felt like I was close to my gramma in Omaha.

I began gathering information. I explained to Fred that this would be a good opportunity since he owned a printing company and other media outlets. To me, this made so much sense for him. Secretly, though, it made so much sense for *me*. You see, my grandmother spent many years working in

Omaha. She was only home on the weekends. I rarely saw her in high school. I was infatuated with Omaha.

As a child, my grandparents took me to the zoo, out to eat, shopping, and many other activities there. I felt alive in Omaha. This magazine only amplified that feeling.

I was clueless on how to buy a business, though. When the numbers came back, I was shocked. Not only did I not have that kind of money, I had no idea where to get it. My boss had no interest but told me I should pursue it if I wanted to and that he would support me.

I rarely spoke about it with Chad. I didn't feel he would understand or have the same passion about it as I did. I didn't want anyone squashing my dream. I had to have this magazine. I dreamed of the things I could do if I owned my own magazine publication. It was all I could think and research about. I found the owner, Jack, on LinkedIn and made sure to connect with him. I kept looking it up, checking the website, and trying to muster up the courage to reach out to him.

One day, I was looking for the listing again on the broker's website and discovered it was gone. My heart sank. I began to cry. Had it sold to someone else? Did I miss my chance? I remembered connecting with Jack, so I went to his LinkedIn profile again. It still showed him as the owner.

Hmm. This is odd, I thought.

I gathered up the courage and reached out to him. Perhaps it had really been sold, and he hadn't updated his profile. I was so nervous. When he responded he indicated that the magazine hadn't sold, but its contract with the broker had ended.

We began a series of discussions around the purchase. These discussions took just over a year. We went from one

end of the spectrum to the other. On some days my odds were looking good, on others he basically told me to fly a kite.

On March 4th, 2016, I was driving home from a print show in Minnesota I attended for my job at the printing company. I was on the interstate and listening to music. The song "Free Bird" by Lynyrd Skynyrd came on. I recalled my stepdad, but even more importantly, remembered that it would have been his birthday. I made a mental note to check in with my sister later and kept driving.

Not too long after, my phone rang. I saw it was my husband Chad, so I answered.

"Carole, I just got a call from the Beatrice Police Department," he began. "They found your mother. She died." There was sadness in his voice.

I was driving about seventy-five miles per hour and learned that my mom was no longer with us. While I've had to bounce from tragedy to tragedy, this one was hitting me hard.

"Are you okay, do you need me to come get you?" he said after a little silence.

"I'm headed home," I said. "I'll be fine. I need to call Hayley."

I hung up and tried to call my sister. Nothing. She wouldn't answer. When I got off the interstate, my sister's ex, Jesse, who still had a good relationship with my mother, was calling me.

"It's Teresa," Jesse said. "She died."

"I'm on my way. I will be there in about forty-five minutes." I said, as I finally started to sob. I hung up and called Chad to let him know that I was going to Jesse's apartment first.

When I finally got to his apartment, I hugged Jesse like he was still family.

"She meant so much to me," he said, shaking. "I can't believe this is true. I just saw her the other day."

I continued to hug him. I wasn't sure what else to do.

When I finally connected with my sister, there were tears, but it was something we had become used to. Now it was basically business. What did we need to do and who was going to do it? She was trying to find the time to come back.

That night I checked the unread messages from my mom. The ones I had stopped responding to. She had sent me the lyrics to the song *One Headlight* by the Wallflowers just the day before. I pulled the song up and listened closely. They sang about dying from a broken heart. That was her. She missed my stepdad. It had been years without him, and it wasn't any easier on her.

When we were finally able to go through her apartment, we found a rolled up hundred-dollar bill by her bed where she died. The messages on her phone indicated she had been out getting high prior to her passing away. She was done and checked out. To her, without him, there wasn't much worth living for.

What remains confusing to this day is that she also messaged that she was excited to finally have her own place to make her own chili recipe. When cleaning out her otherwise cluttered apartment we found all of the ingredients to chili and the receipt from a few days prior. She never got to make her recipe.

<p style="text-align:center">* * *</p>

With the passing of my mother, I began to fight harder to purchase Edge Magazine. I was going to make this happen, and I wasn't taking no for an answer. Months later, Jack and I finally met in person. We met over lunch to get to know each other better. He spoke about his family and asked about mine. I was brief and also explained that I had just lost my mother earlier in the year. I explained to him that I had been through a lot and I know that I would be the best person to take over his magazine because no one would be more passionate about it. He excused himself to the restroom and I was sure I saw a tear in his eyes.

In the fall, we came to an agreement. It involved me putting a second mortgage on our home, and I wasn't taking no for an answer from Chad either. I think he knew that and hesitantly signed the loan documents.

We announced the change of ownership on January 2, 2017, via social media and then officially in the February 2017 issue of Edge Magazine. Since Edge is a bimonthly magazine, my first publisher letter came out in the April 2017 issue. To this day, the managing editor, Kathy, still writes, edits, and manages the day-to-day operations of Edge. Without her craft, my letters would be a mess. Believe it or not, writing has always been a challenge for me, especially starting a new piece of writing. Oddly enough, that is one of the underlying reasons for writing this book; I wanted to tackle one of my challenges and grow from it.

CHAPTER 3

TALKING TO A CUP
OF COFFEE

It was June of 2017 when I left the printing company and took a new role at the pet supply company. Now owning a magazine in Omaha, I needed employment that better supported my schedule. I spent one, sometimes two, days each week traveling to Omaha to meet people and grow my new business. Many evenings I drove home late only to have a commercial business that still needed cleaning. I wasn't about to give up the cleaning business and the income that came along with it—especially since I had the magazine that was still in growth mode.

I recall the memory of my previous position at this company when I was faxing and following up right before I hit thirty. As I sat down at my cubicle after four years of being gone, I was reminded of what my larger goal has always been here—round two of helping with faxing requests and following up on open orders. It was a bit more automated at this point, but still boring. The understanding though was

this time, I was trusted to help grow the company's private label division.

I was setting out to prove to my mentor and boss, Doug, that I was capable of being part of the management team. The environment and staff were how I remember them. I was never a fan of being an employee here. It was hard to tolerate people who talk negatively about their boss, spend forever on cigarette breaks, call in sick constantly, and drain you mentally. I kept telling myself that I was meant for more and I needed to prove it.

Fast forward a few months and I was learning about the private label that I would help grow. I was meeting vendors, organizing products, and my desk was being moved into the other building where employees package and store the private label products. I was so excited that I didn't care that my office has prison peach-colored walls, and my desk was made up of folding tables. I decorated it to fit my personality and set out to grow this division.

Learning the nuances of a private label made me constantly think about the process: build a brand, create products, and make money while you sleep. It seemed easy enough. I became obsessed with what products I could build a brand around and what my mission would be. I was always writing ideas down and researching.

I loved my boss and mentor. Doug and I had a great relationship outside of work, too. He had been a mentor over the past several years, but I realized that we were similar people. It was hard to work for him when he wanted to control every aspect and not allow me to make decisions. I found myself often wondering if he would just let me do the job I was hired for, what could I really do for this label and for him.

I started my days with lots of coffee and ended them with decent amounts of bourbon. These two things are what I attributed much success to. Coffee was the elixir that woke my senses and started my days. Bourbon was the liquid gold that slowed me down and let me relax in the evenings.

One day, I was sitting at my desk drinking coffee. I loved the sensation of wrapping my fingers around my mug and feeling the warmth throughout my body. It hit the soul. Everything else was going wrong that morning and it was only 9 a.m. I stared at my coffee and said, "I wish you were bourbon right now." Then it hit me. If you can get vanilla coffee and hazelnut coffee, I wondered if you could buy bourbon-flavored coffee. I spent the next couple of hours hunting the internet for bourbon coffee. I found several interesting brands. Some said that they were artificially flavored, and others said that they were barrel-aged. Being a true bourbon enthusiast, I was more inclined to try the barrel aged coffee, which I did order from a couple different brands. Most of these coffees came in whole bean varieties. I hadn't purchased whole bean coffee before, but being up for trying something new, I made the purchases.

As I looked at options, I made a mental note to swing by Wal-Mart and grab a grinder. I recalled the grinding sound and smell each morning because my grandpa preferred to grind his beans fresh and use purified water.

Being an adult now, I understand how precious that time was for him each morning. The smell creeping up the stairs was intoxicating. I didn't care for the taste of coffee in high school, but the smell was lovely. Besides, my coffee drinks were more cream, sugar, and flavors if I were going to drink it. My grandpa reminded me that I didn't like coffee unless I drank it black.

Several years after drinking coffee doused in sugary creamers, I went cold turkey with black coffee. Instantly, I lost nearly five pounds after eliminating those calories from my diet and soon began to appreciate coffee for what it really was.

A few days later, my whole bean, barrel aged coffee showed up. I didn't even care that it was already dinnertime. I opened the bag and breathed in deeply. The smell was amazing and unlike any other coffee scent. I poured the beans into my new grinder and turned it on. The smell of the freshly ground coffee was even better. I anticipated the flavor while it brewed and filled the house with bourbon and coffee scent. One sip, and I fell in love. This special coffee became my everyday coffee. I loved starting my day with something so indulgent and exquisite.

I often worried about the number of jobs I had to work just to get by. I was obsessed with finding a way to make money without physically working. The idea of having my own brand and label was still weighing on my mind constantly. Could bourbon barrel-aged coffee be that product? After all, I loved both bourbon and coffee. Could I get behind bourbon coffee? I looked up the brand I've been purchasing and saw a wholesale option on their website. After speaking with them and getting some numbers, I found out that I could, in fact, private label. I became obsessed with the idea of my own brand of coffee.

When I shared the idea with Chad, he didn't seem too surprised. I guessed it was because he was learning that when I set my mind to something, I won't change it.

I took a trip to their roaster to see the process, meet the owners, and narrow down bulk pricing. After I got home, I was sure this was what I wanted. Then I became more inquisitive. What barrels are the coffee beans aging in and what kind of coffee beans are these? If I was going to build my brand around this, I needed to know everything about the manufacturing process. This information wasn't going to be shared with me. I started to think I wouldn't be able to make this work.

But at that point, I had already created a brand and spent money on a logo and trademark, so I needed to figure out the obstacle. I had this thought: Why *can't I just produce this coffee myself?* After all, I can get coffee beans and I can get at least some local distillery barrels.

My designer, Q, suggested a friend of his that roasts coffee and put me in touch with a guy named Matt. We arranged a phone call. Thinking he was going to think I was crazy, I explained my idea. After a short conversation, he was willing to help me out.

Brickway Brewery and Distillery in Omaha, Nebraska, had the barrel I wanted to start with. I pulled up in my white minivan to pick up the barrels. Although they were a bit bigger than I thought they would be, we put the seats down and loaded it up.

May 17, 2018, we filled the first barrel. There was a bit too much liquid in the barrel so we drained out the remaining bourbon, poured it in 3 separate cups, and Matt, Chad, and I all said cheers to the future. I had no idea if that barrel would be a onetime project, a business, or a hobby; but after all obstacles, I was on the way to having my own barrel aged coffee. Clout Coffee was being born.

It was the row of seeds starting that I had been obsessing over for years. I was ready to nurture them.

<center>***</center>

It was a great fit that my coffee roaster was in Omaha because I was still coming to town each week to spend time working on Edge Magazine, which was doing quite well. It was around this time that I was able to take the profits from Edge Magazine and get Clout Coffee up and going. My plans for having several businesses that complemented and fed each other were coming together.

There is much to be said about the courage to start a business. I had dreamed of starting my own ecommerce coffee business while building a brand around encouragement, empowerment, and entrepreneurship. What I didn't realize was that it was going to be hard work and long hours.

I still kept my cleaning business, which had grown to take on enough contracts to keep me busy every day. I started bringing my boys to help me clean the way my gramma had brought me years before. This is when I truly realized how much help I was to her. My boys shortened our work time and usually insisted on fast food as payment. Not only were they helping me and learning about hard work, it was time well spent with them.

CHAPTER 4

SHALL WE DINE? THE BEST IS YET TO COME

———

A few months before our first Clout Coffee barrel was filled, Chad and I learned that the police department he had been at for almost ten years was going to be disbanded. It was all said to be rumors and hearsay, but it proved to be true.

When my husband's job was going to be eliminated in Fairbury, he did what he had always done for me and let me have my way. We decided to move to Omaha knowing that I was still passionate and involved with Edge Magazine and was just starting Clout Coffee.

In 2018, our house went on the market in April, a month before we filled our first barrel with coffee. In June, and much earlier than we planned, we found out that there was an opening in a townhome in Elkhorn, but we needed to take it right away if we were going to get the spot. Even though our house wasn't sold, I was so excited to move in.

I knew my husband was nervous. He's always been the safe one in our relationship and I am the free spirit. I was ready for a change. I had begun to dislike Fairbury. It was

filled with small-minded, gossipy people, many of whom couldn't see beyond their weekend plans. I was over it. Spending each Tuesday in Omaha every week was just enough temptation to get me to go there.

My Omaha friend and mentor, Jay, heard me complain many times over about having to go back to Fairbury and that one day, I was going to live in Omaha. I dreamed of it. The two-hour drive home reminded me of it. I couldn't wait to tell him that we were finally relocating. Plus, I needed to ask him permission to use him as a reference on job applications. I let him know that I was going to look for full-time employment so my businesses could keep their earnings and I could keep them growing. Jay was an agency manager at an insurance company.

Considering that years before I had worked in the insurance industry and that this job had flexible hours that let me tend to my other rows, I signed the contract he offered.

Historically, when I make huge life changes, there are many that happen all at the same time. This was no different. We publicly announced Clout Coffee on May 17, 2018, and the boys and I moved into our townhome in early July right before the first barrel of Clout Coffee was roasted. It was the same month that I began as an agent at an insurance company.

There were so many things to make sure were in place along with relocating a family. More so, my husband had to finish out his time in Fairbury and didn't move with us until that September.

We made our way through a year when I began to realize there wasn't enough focus on the restaurant industry in Edge Magazine. I began dreaming of creating my own branded magazine.

<center>*****</center>

In the fall of 2019, we added a second publication to the Edge Publishing brand. Dine Magazine came to life to focus on the food and beverage industries in Omaha, Nebraska, with the intention to expand to a more general Nebraska focus as time went on and as revenue would allow.

Sharing Nebraska-based stories about food, beverage, and suppliers to the industry is a good feeling. Having a long-lasting print platform and opportunity to elevate other people and businesses is an amazing feeling. Sharing stories digitally is great. Sharing stories in print is priceless.

Having a second magazine isn't enough. I want to replicate this model throughout the country. I envision having several Edge and Dine Magazines throughout North America. I dream of holding a conference annually for publishers and editors where we'd celebrate the stories, victories, photos, and editorial content, all while educating and empowering them to do more, be more, and give more, all while drinking a cup of Clout Coffee.

<center>*****</center>

It hasn't been all glory though. Edge Magazine did well in 2017 and 2018 and that allowed me to start Clout Coffee mid-2018.

In 2019, not only were my businesses changing but my family had all relocated from a small town to a city—my garden became chaotic. Stress set in. Early 2020, the pandemic hit. We are still going through that as I write this book. My coffee business didn't skip a beat, but my magazines took a

toll. My role as an insurance agent has also maintained its earning capacity.

I'm impatient, and when I make up my mind to do something, I don't care how rough the road is or if I have to go it alone. Historically, I choose the worst time to do anything and always pile way more onto my plate than what I can handle. I've learned, though, that I can actually handle anything that I set my mind to, and because I allow myself to dream, plan, live, and grow outside my comfort zones, I can do anything.

I once heard that true wealth goes three generations deep, meaning that once you've pooled enough resources to help three generations survive, you've left a legacy. Right, wrong, or indifferent, that has always stuck with me. Not only do I think about seeds in my own garden, but also setting some aside for others.

CUP OF CLOUT

Unlike my early childhood, I learned to swim and became quite confident in it. If you know how to swim, you don't care how deep the water is. You jump in anyway.

Entrepreneurship is a large and deep pool. It isn't for everyone. It is a blessing and a curse.

The larger your garden is, the more important your team becomes. You can't go it alone. Don't forget about those who step in and step up when you need it most.

Above all else, keep growing.

EPILOGUE

———

Writing this book has been an intimidating journey. It has required excessive amounts of coffee and bourbon. I've told myself for the past two years that I wanted to write a book. I wanted to share my stories with my boys who, like me, might have questions later in life.

Aside from them asking questions, I want to show them that no matter what life throws at you, get up and keep growing. Take the good seeds and invest them into more good seeds. Take the bad, learn from it, and toss it out the window.

I've had the book title in my head long before the words hit the paper. I get asked time and time again how I do all that I do. I figured writing a book might better explain it. Everyone has a level of capacity. More often than not, we can actually do more than we think we can.

In November 2019, I made the decision to join a book writing program that would not only help me step-by-step but also provide me with community and accountability along the way. A connection of mine, Fernanda, shared her book writing journey on LinkedIn and I was intrigued. I met her on a Sunday for coffee and she told me all about it. Fernanda was writing a book through the Creator Institute

program and was publishing through New Degree Press. She explained that the process was fun, educational, and rewarding. She gave me Eric Koester's phone number so I could learn more about the program. I texted him before I even left the parking lot. He responded the same day. After an initial call with Eric, I made the decision to write a book.

In January 2020, I announced the book writing journey on social media. I struggled with imposter syndrome and wondered if I really had any stories worth reading. What kept me going was thinking about my children's future. I think about them at the age that I am now and hope I can be there to help them, guide them, and encourage them. But what if I am not able to be? I hope to leave behind a legacy worth reading about.

Also, I brought on a business partner and seed money to the Edge Publishing brand in January. Our goals are aligned, and we are constantly working on our bigger vision.

In March, the Coronavirus pandemic shifted our whole world. Then protests took place. This book journey has helped keep me grounded in an otherwise unsettling time. In thirty-six years on earth, 2020 has been one for the books (pun intended).

In August, I brought on partners and seed money into Clout Coffee. This partnership not only gave me the financial resources to grow the business, but it also gave me a team of people on my side, pushing me to reach a bigger goal and grow the company.

Both business partnerships I've created this year are incredible. I'm forever grateful for the trust, teamwork, and mentorship.

The timing couldn't have been better, I think, to share these stories and this journey with you. When faced with

struggles and adversity, you have control of how you respond and grow. You also need to lean in and lean on your support team. Be there for each other through good and bad.

Along this book journey, I've found more purpose. I hope you walk away from this book with a bit more passion and tenacity than before. I hope you put this book down, pick up a pen, plan out your next move, and go out and kick ass.

This book could have gone down many paths. I chose the one that led to me sharing my childhood and early days in entrepreneurship. I don't know that I will ever feel finished or complete; I'm always thinking of the next phase. Being a published author is one more seed in my garden. I will honor it, nurture it, and see how it can help everything else grow and thrive.

Stay tuned for the next phase. Seed money is something I am working for. What I do with it later will be epic.

ACKNOWLEDGMENTS

———

First, I would like to thank my family. Thank you to my husband Chad. You've seen me at my best and through my worst. I'm not the same person you married, but you've never left my side. I love you.

Thank you to my sons. Hayden—you made me a mom and instantly brought joy into my life. I appreciate your patience and go-with-the-flow character. Mason—your strong-willed nature keeps me on my toes. You remind me of my younger years. Ethan—you are my cuddle bug. You will always be my baby. Logan, my bonus son! You have always had a kind heart. I value the relationship and trust we've built over the years.

Thank you to my sister Hayley. We've spent our lives looking out for each other. You've taught me about unconditional love. I admire the woman and mother you've become.

Thank you to my close circle of friends and other family members. The names have changed slightly over the years, but one thing has remained constant: you've all been an influence on my growth and development.

I'd also like to thank everyone at New Degree Press. I am especially grateful to Eric Koester for believing enough in me to give me this opportunity. Thank you to my editors

Jacqueline Diaz-Mewes and Linda Berardelli. You've both helped me turn this book into what it is today. You've helped me put my thoughts to paper and encouraged me along the way to keep going!

Finally, thank you to everyone who supported my pre-order campaign and helped me reach my fundraising goal. Each and every one of you helped me to finish strong and gave me more encouragement to complete this adventure. I would also like to thank those donors who contributed anonymously.

Amy Dong	Chad Sprunk
Kasie Leeling	Hayden Heckman
Shane Myers	Mason Sprunk
Dale Eesley	Ethan Sprunk
Magdalena Axtell	Kathy Rygg
Susan Leeling	Josh Brink
Blake Martin	Laurie Hellbusch
Charles Sederstrom	Angela Reding
Michael T Meyer	Stephen Stinn
Christopher Corey	Martin Pugh
Jennie Warren	Eric Koester

Anna Hartman

Shelby Heldt

Tom Kealy

Melvin Stuart

Gretchen Bren

Chris Tierney

Britteny Ferrin

Becky and Jay Miralles

Jona Van Deun

Crystal Bartels

Nathan Newhouse

Brandon Posivak

Liz Rease

Felicia Kirke Weaver

James Kernan

Mary Kate Gulick

Sandy Spady

Keia Jensen

Kelly Murkins

Bonnie Lacy

Alex Pearson

Shannon Bingham

Pete Wheelhouse

Jennifer Bronson

Tricia Danielsen

John L. Hoich

Marla Teegerstrom

Jared LeSuer

Ryan Steffen

Joseph Kenney

Scott Wheeler

Gabby Christensen

Zac Triemert

Jane A Dworak

Lori Humlicek

Gabriel Ruiz

Rachel Benson

Danielle Easdale

Lisa Cummings

Hassan Igram

Melissa Glenn

Stacie L Gamerl

Rod Larsen

Lisa Harbin

Lauren Bannister

Sheila Long

Sandra Rank

Jenn Haeg

Molly Merrell

David Meyer

Ginny M Gohr

Darcy Michalek

Nicole Bianchi

Nic Bianchi

Josh Vice

James Manske

Kevin Karstedt

Jill Fahrer

Tonya Ludwig

Michael Johnson